TATTOO COLORING BOOK FOR ADULTS

77 INTRICATE DESIGNS FOR SUPREME RELAXATION

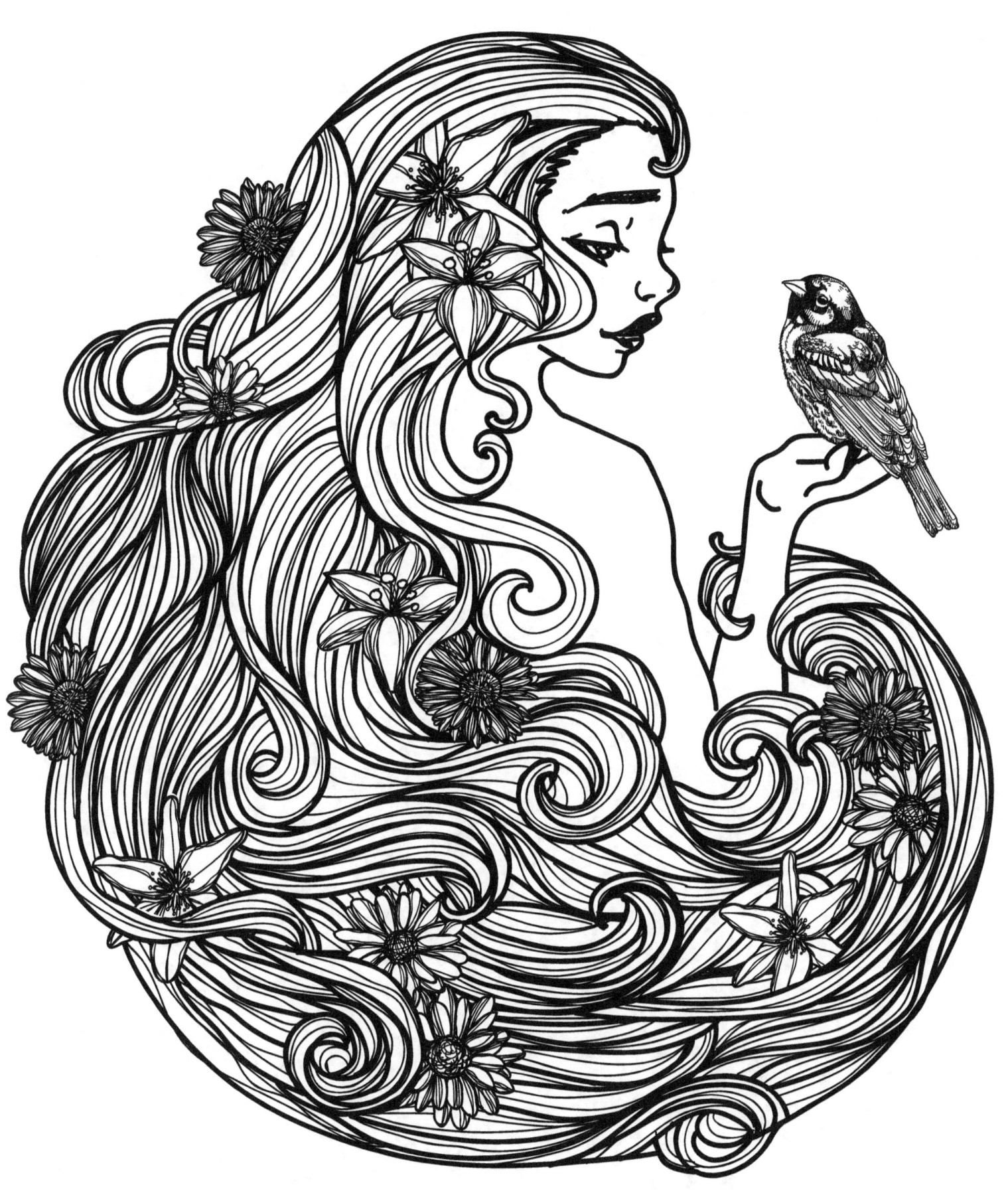

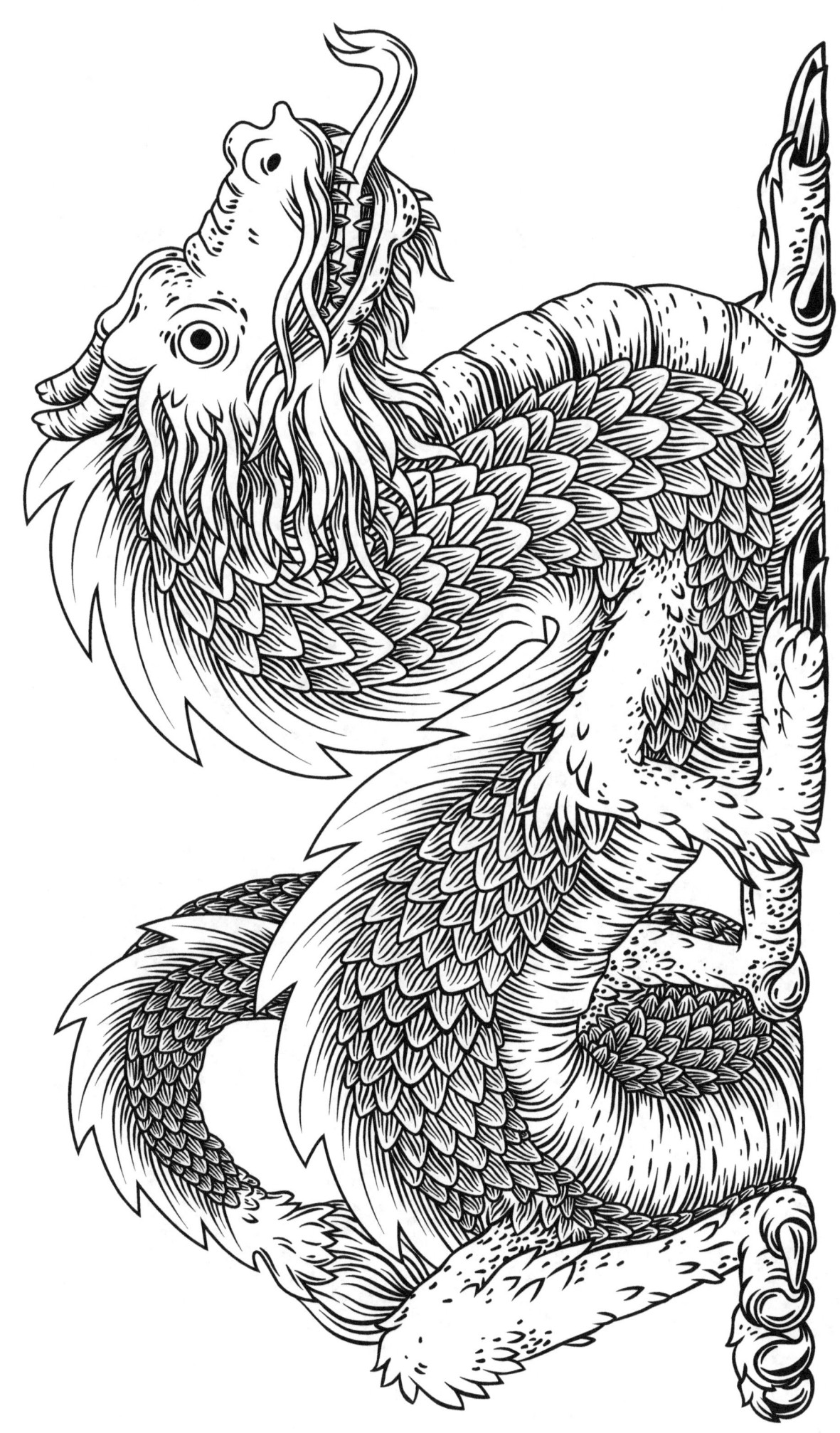

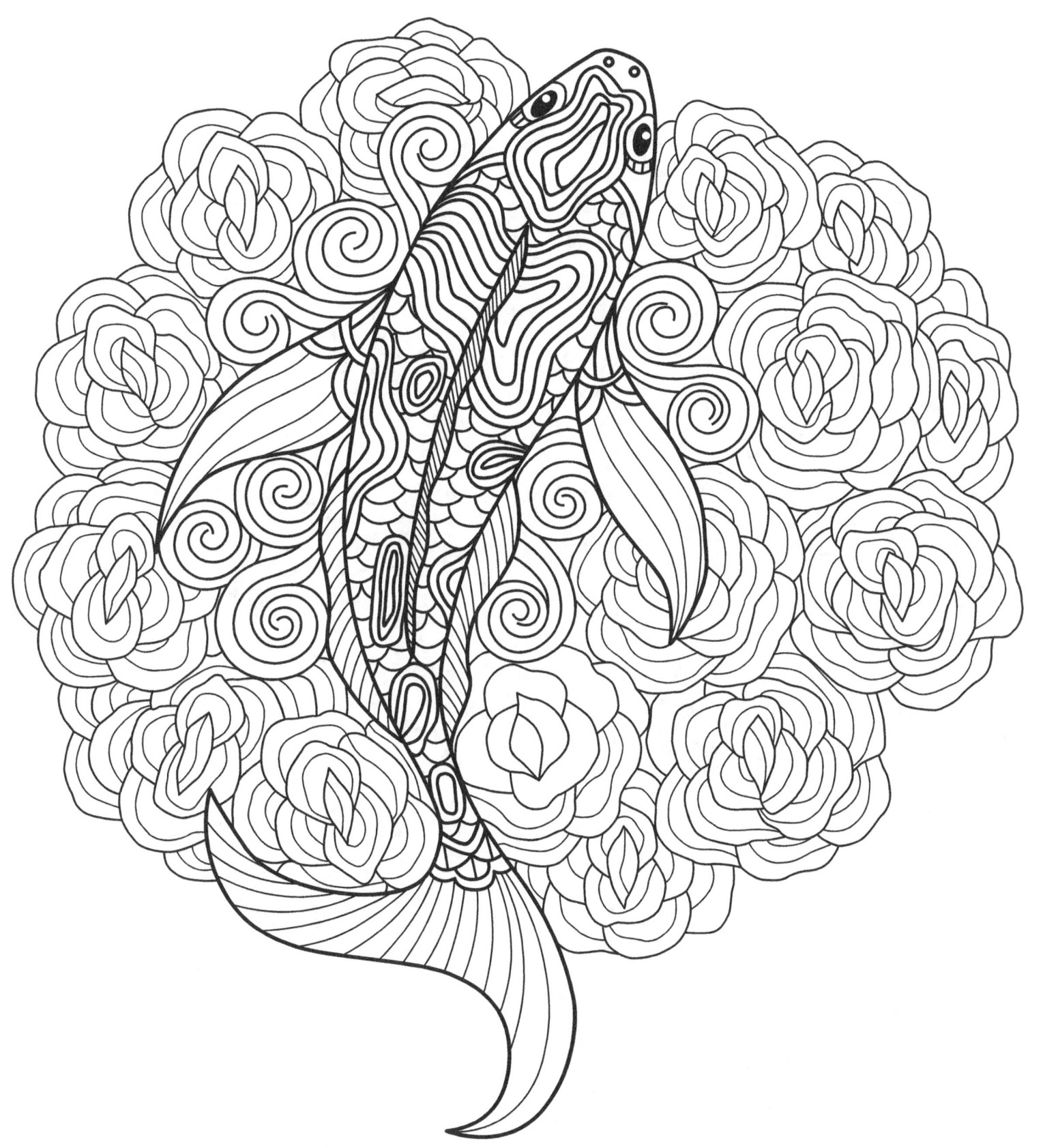

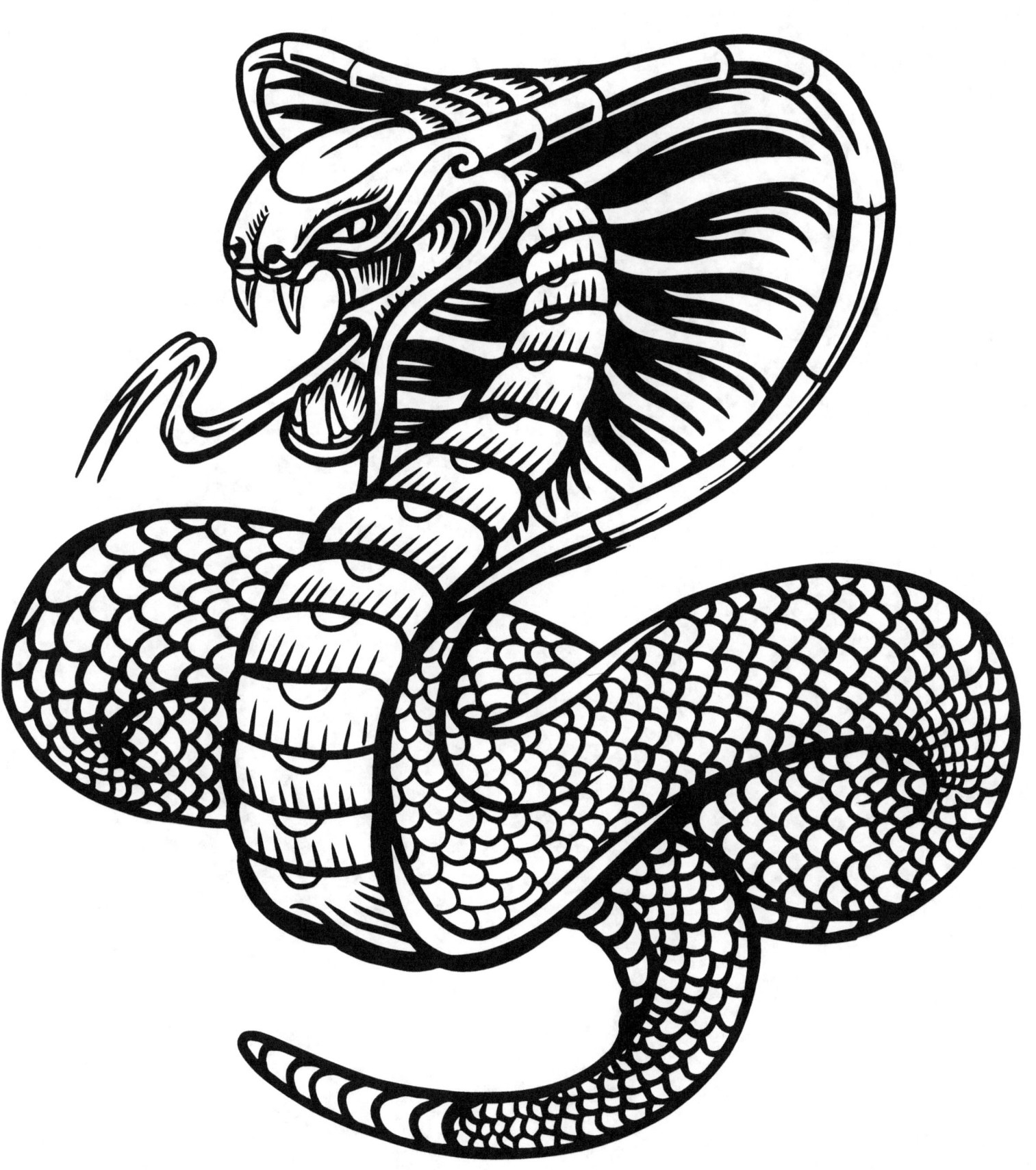

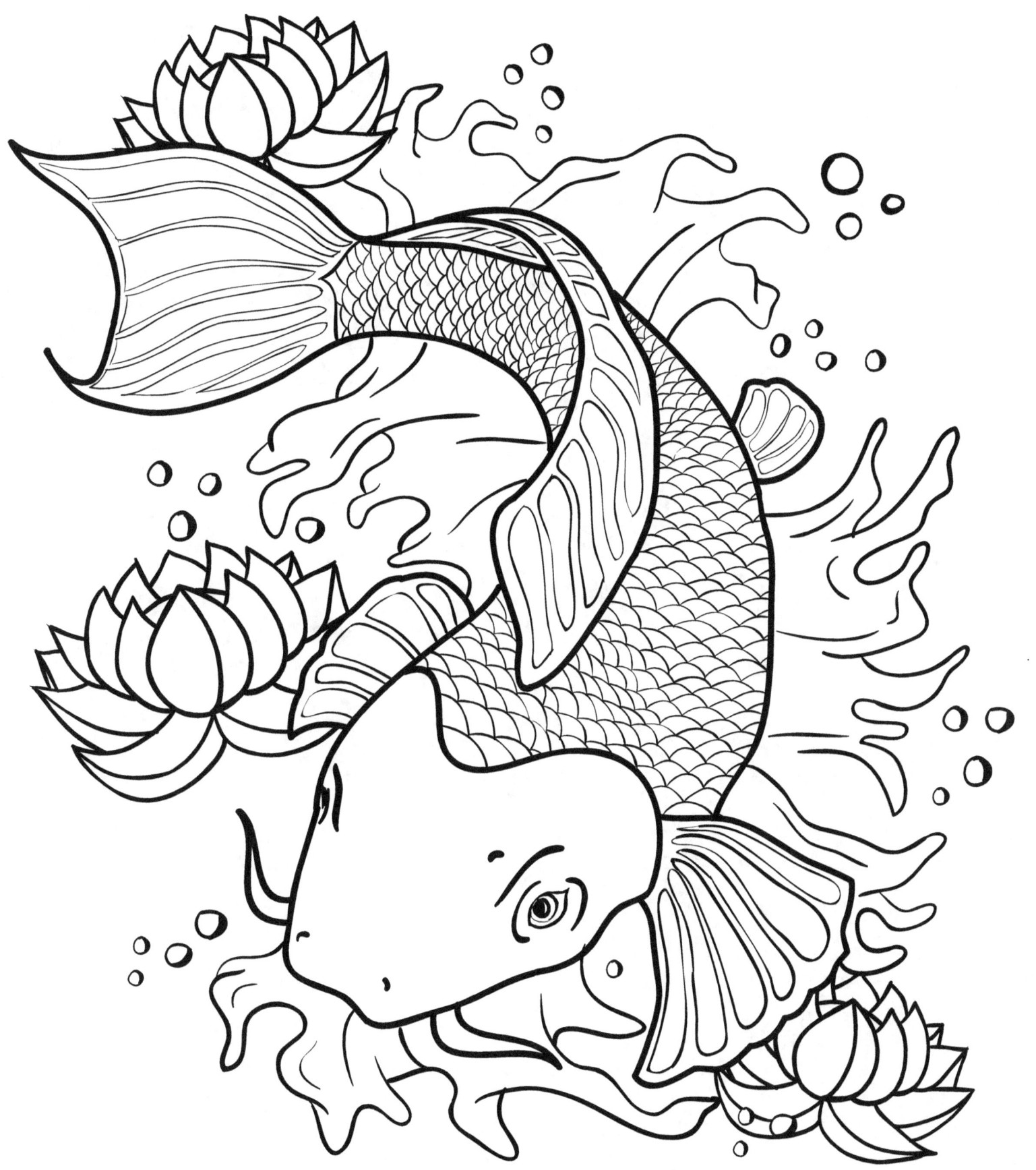

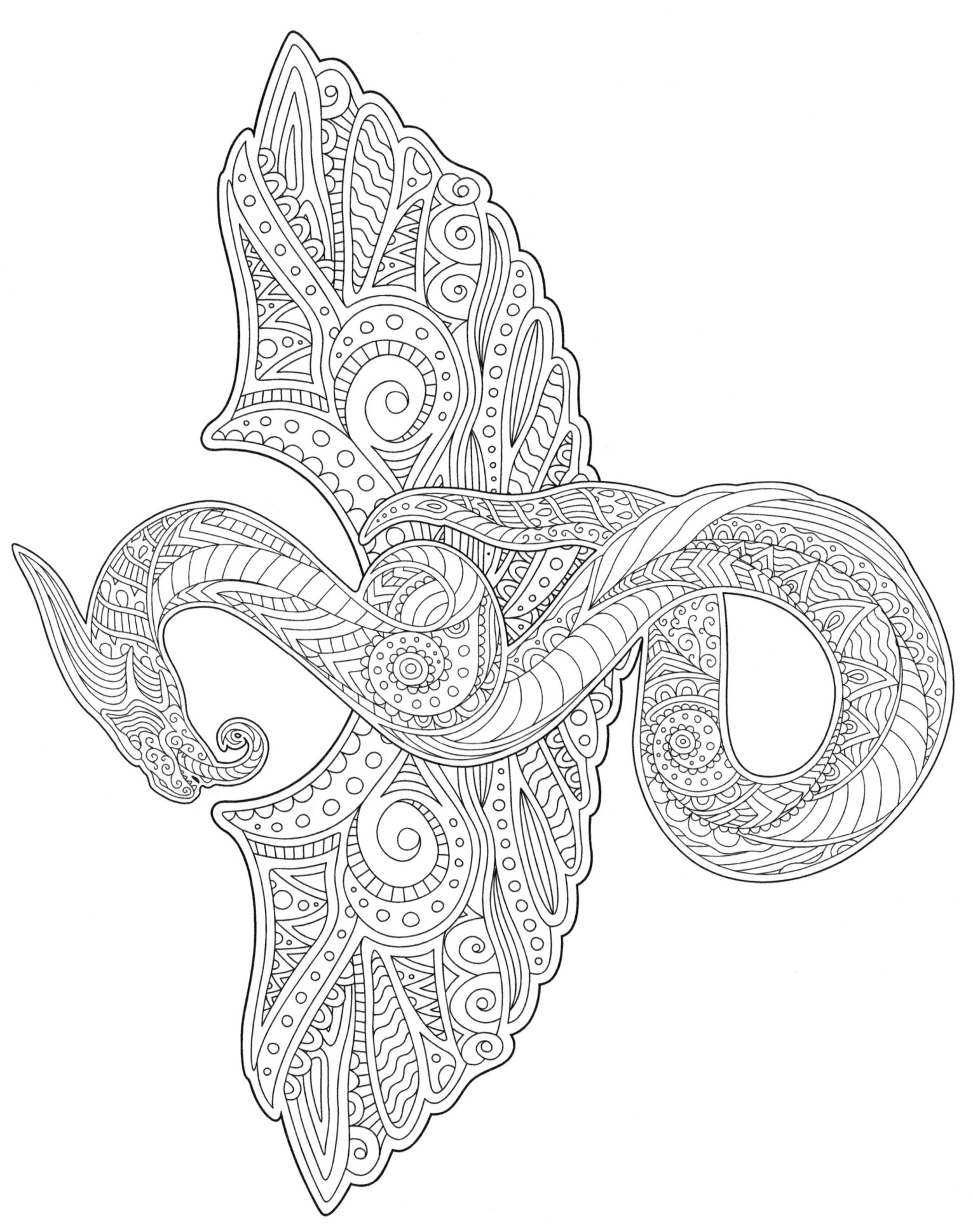

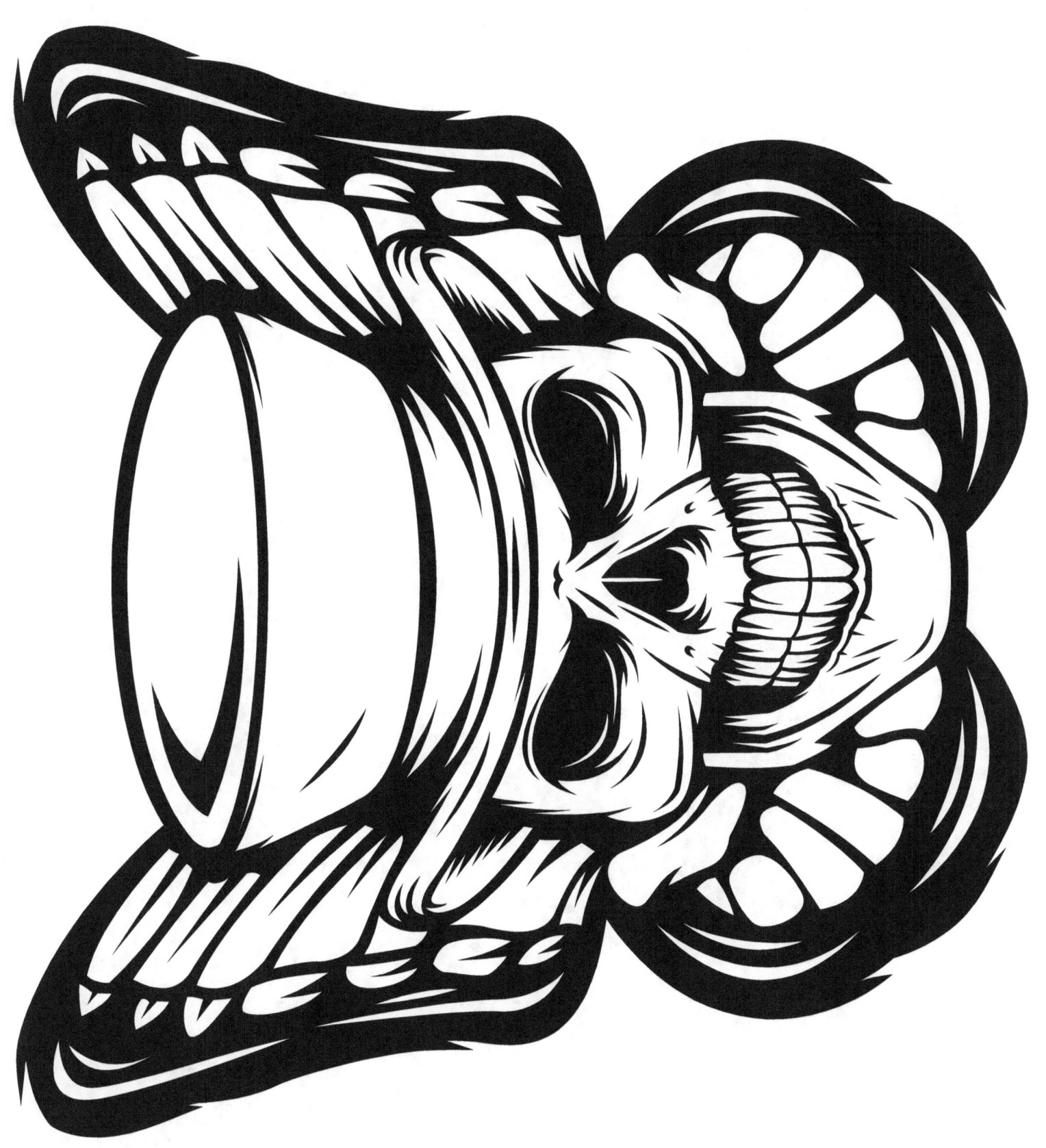

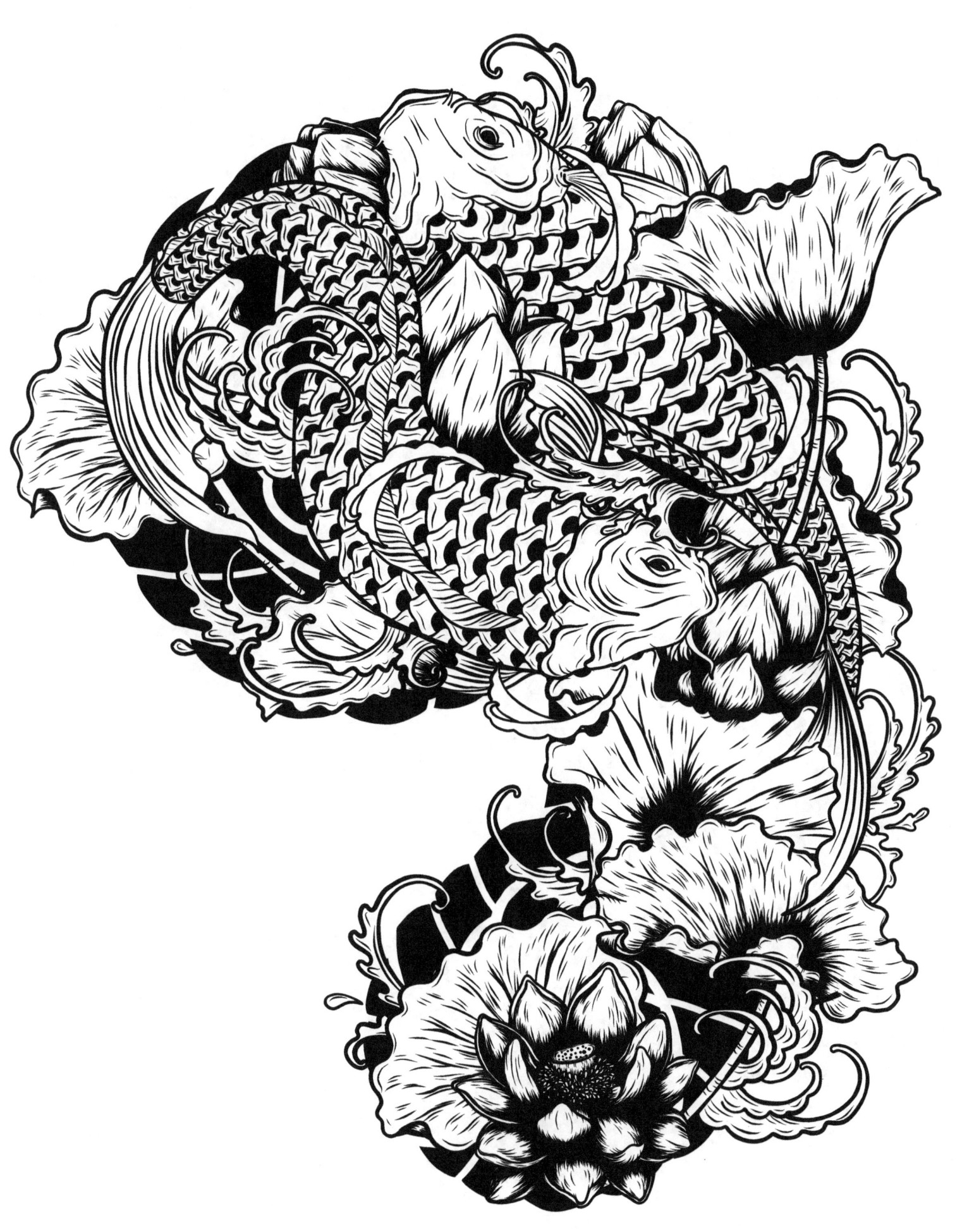

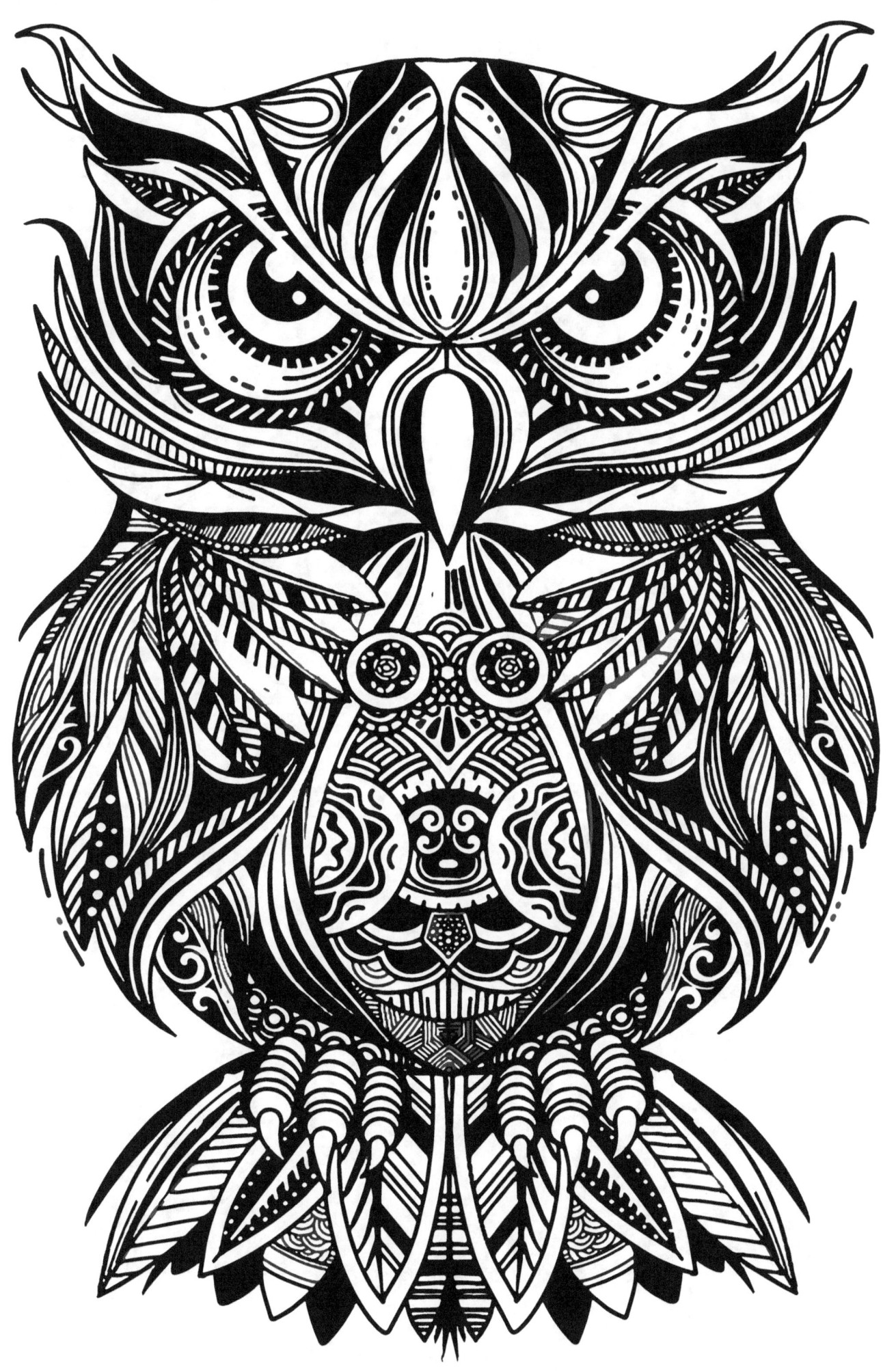

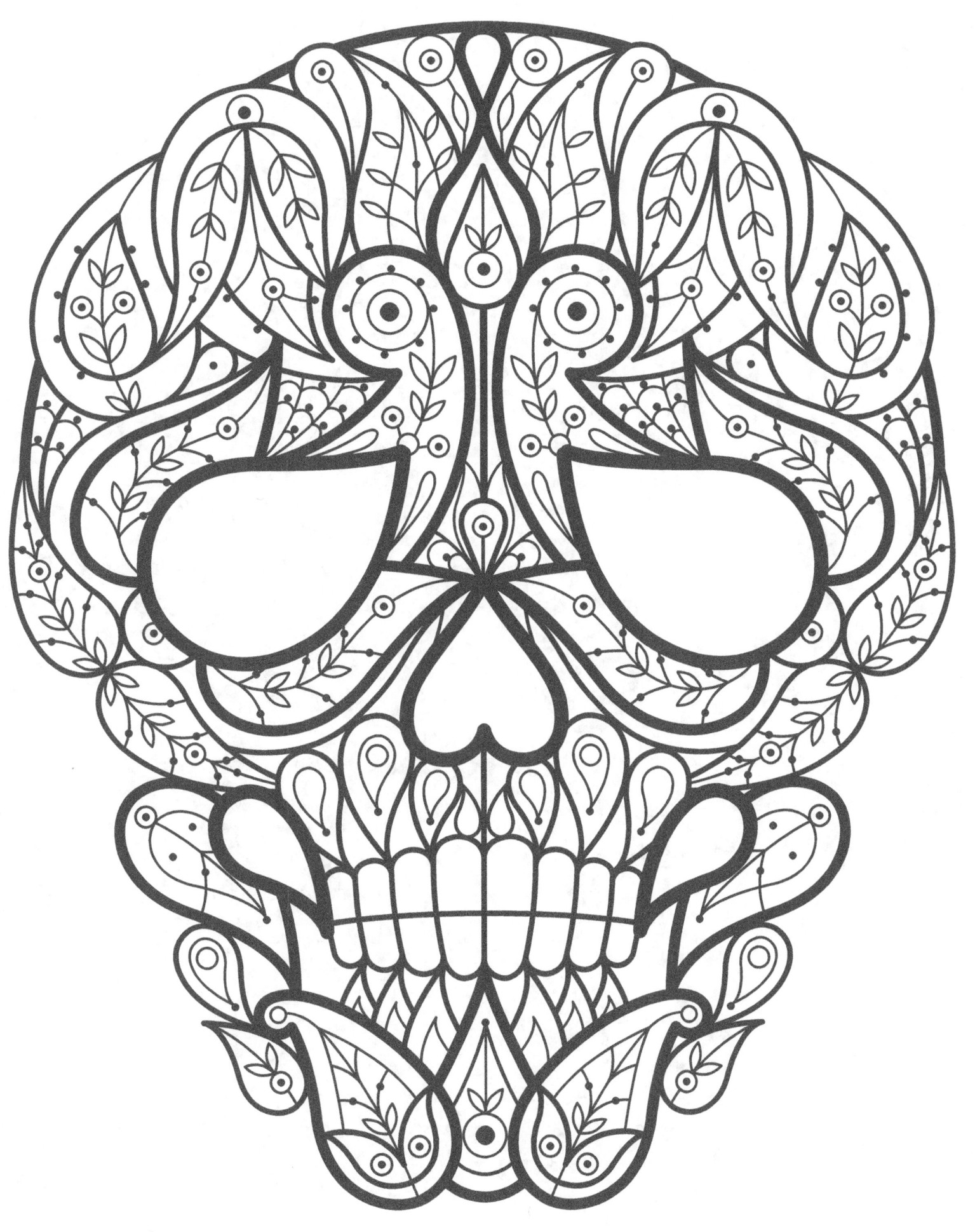

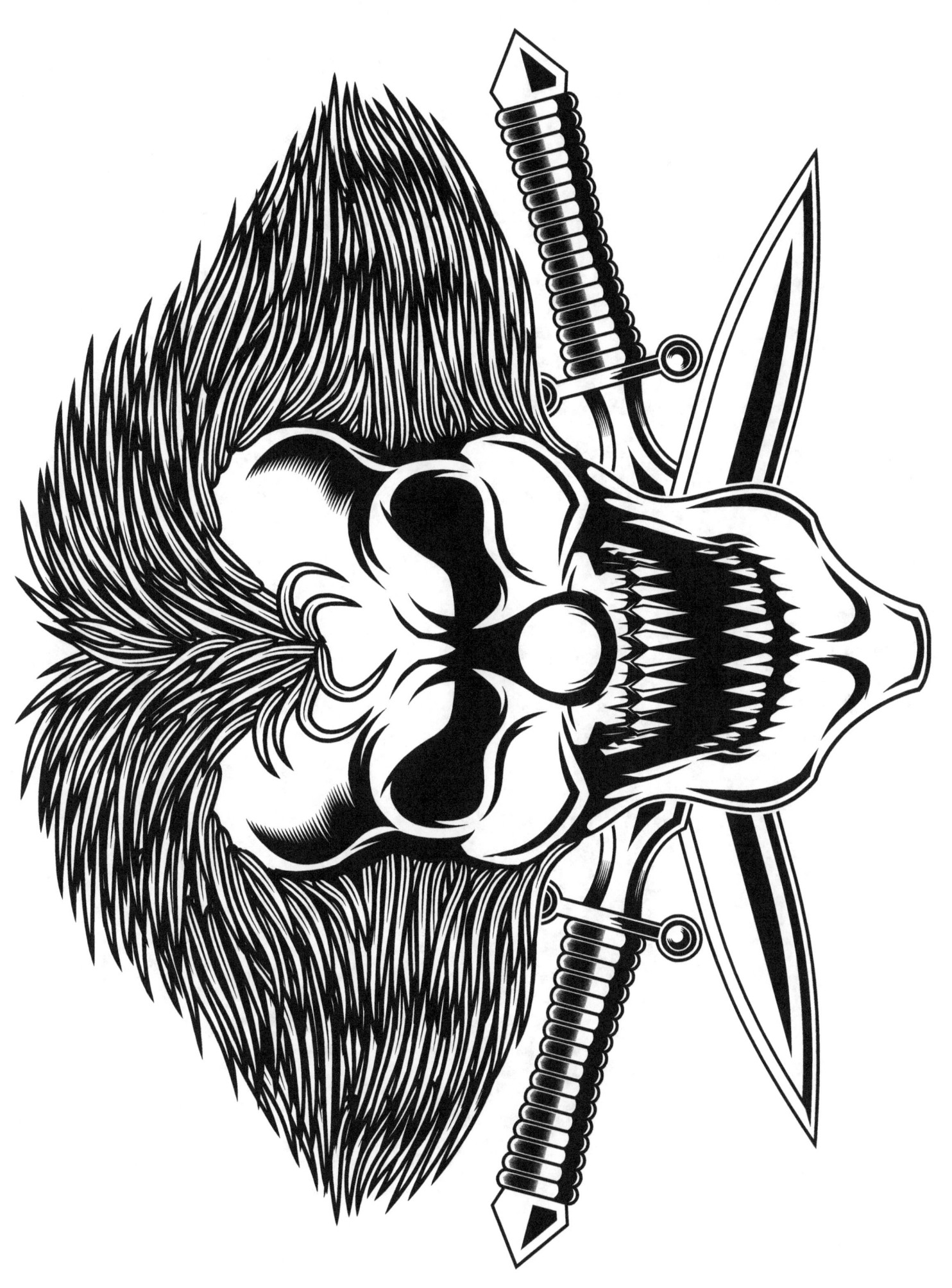

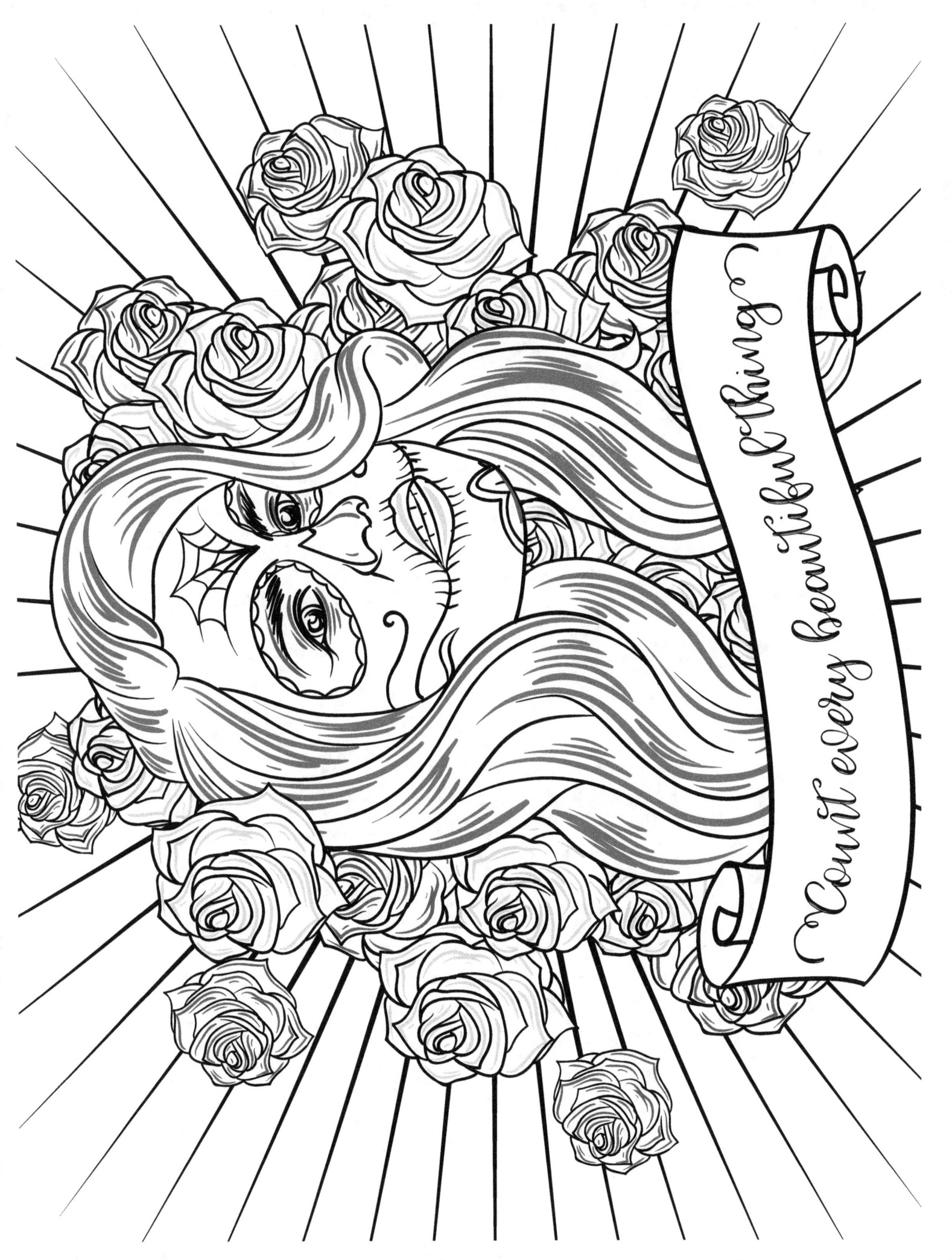

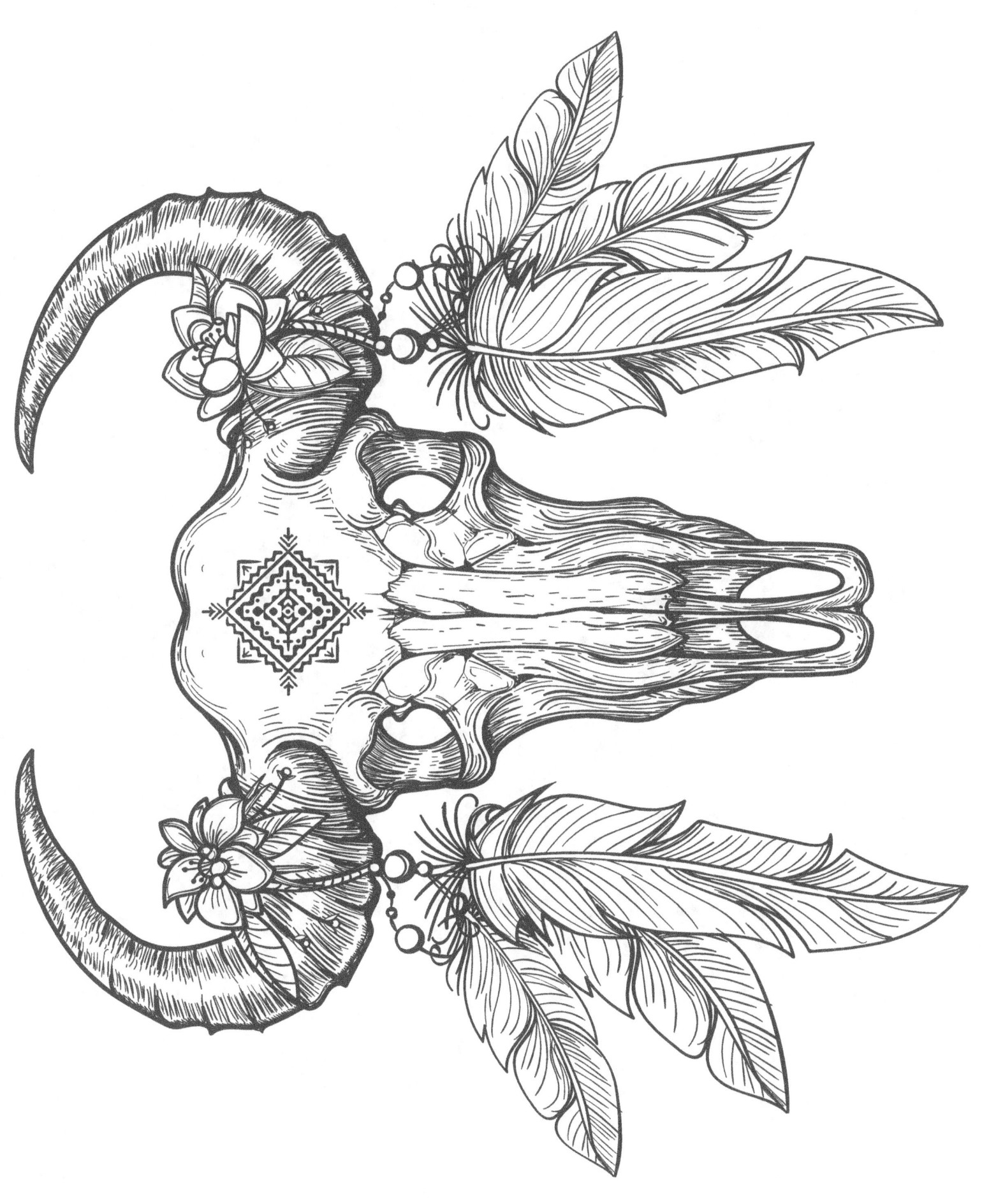

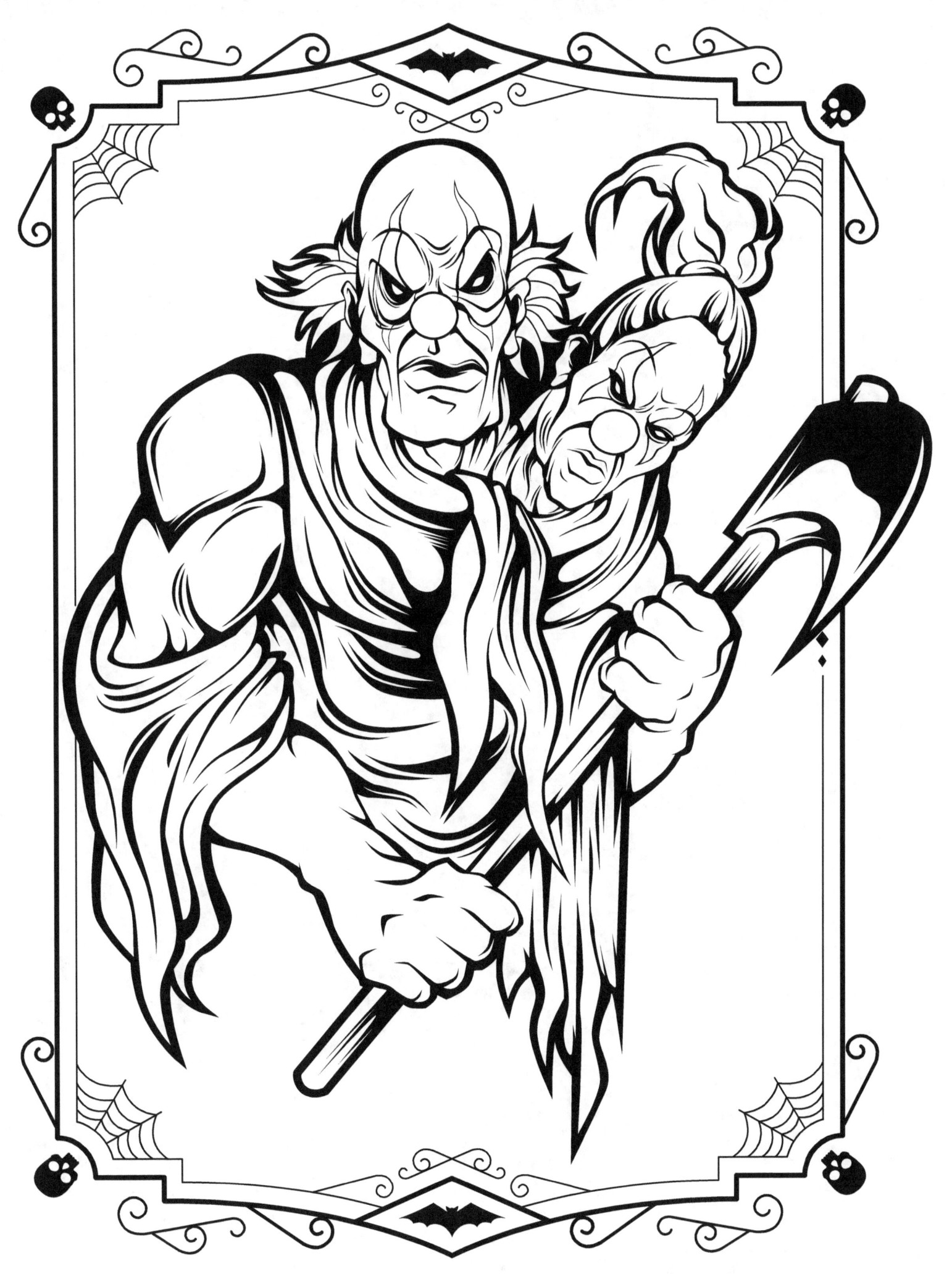

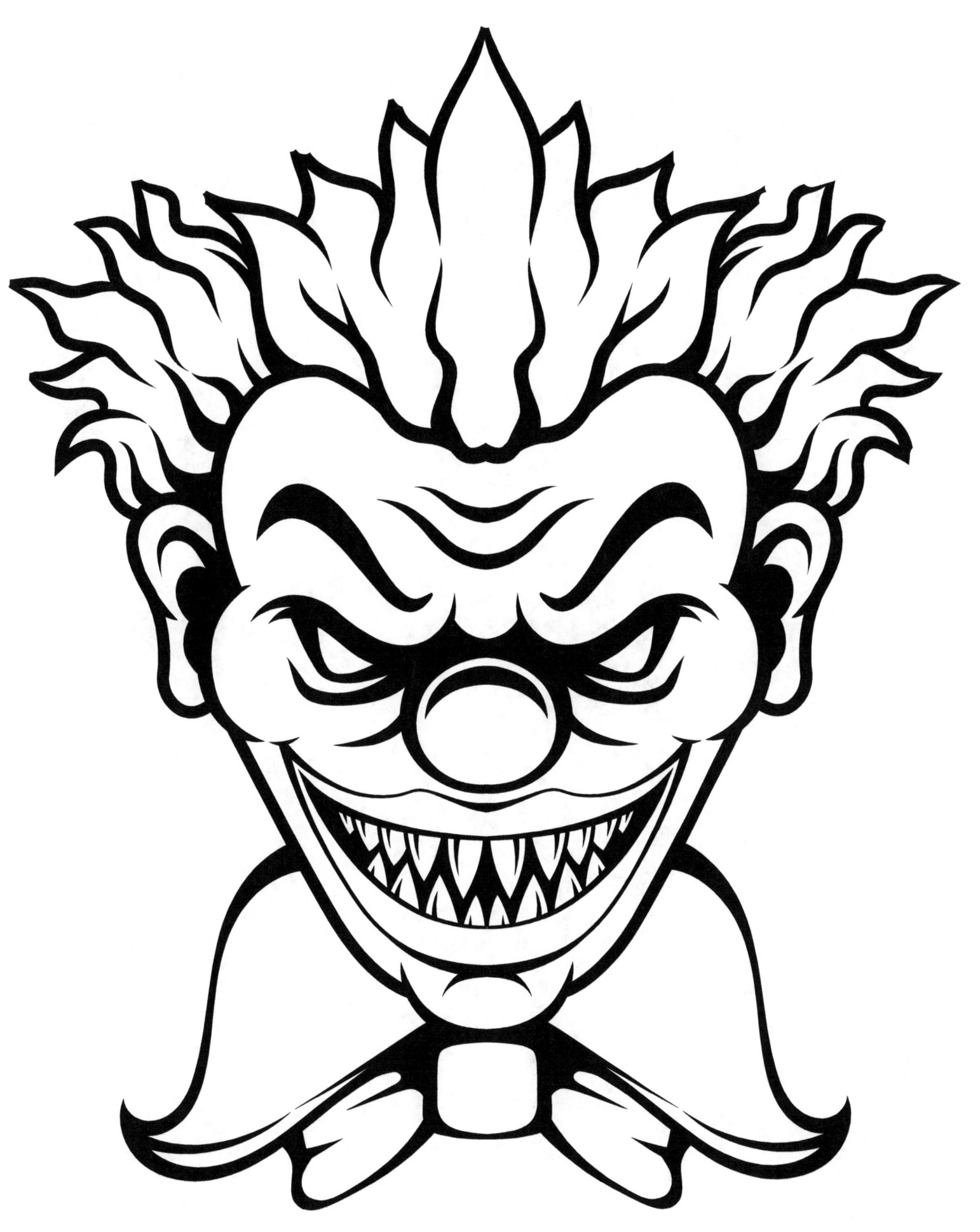

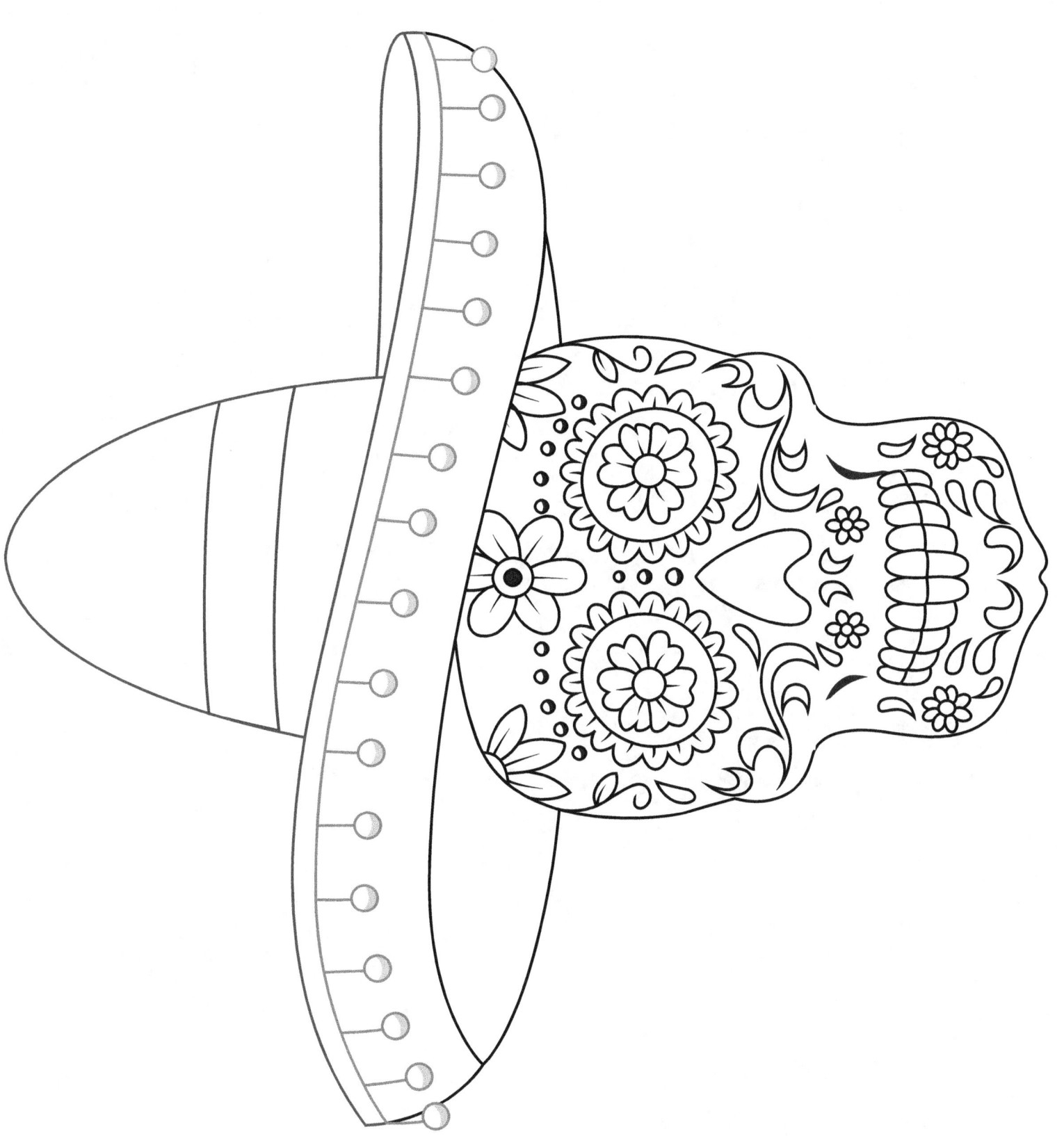

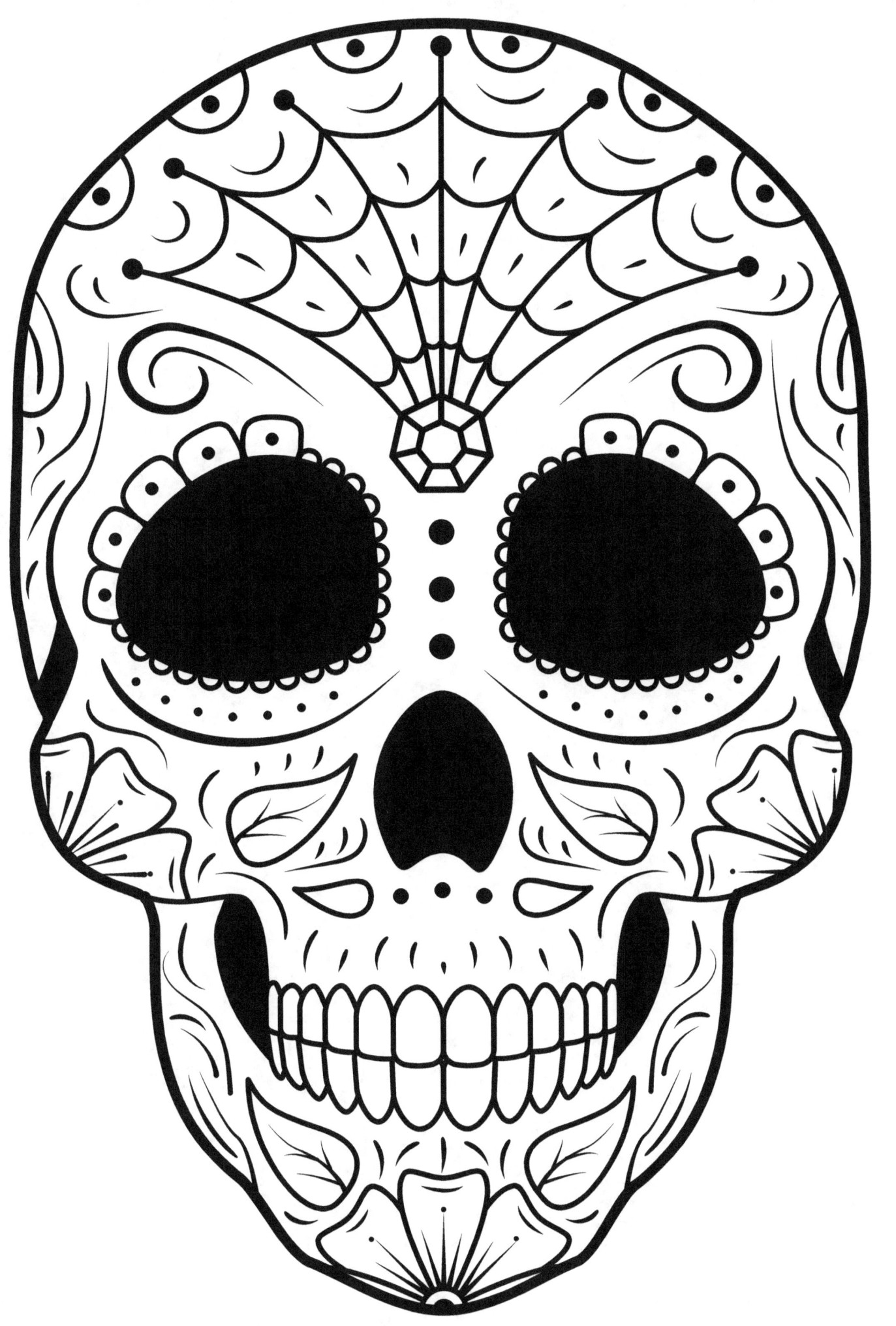

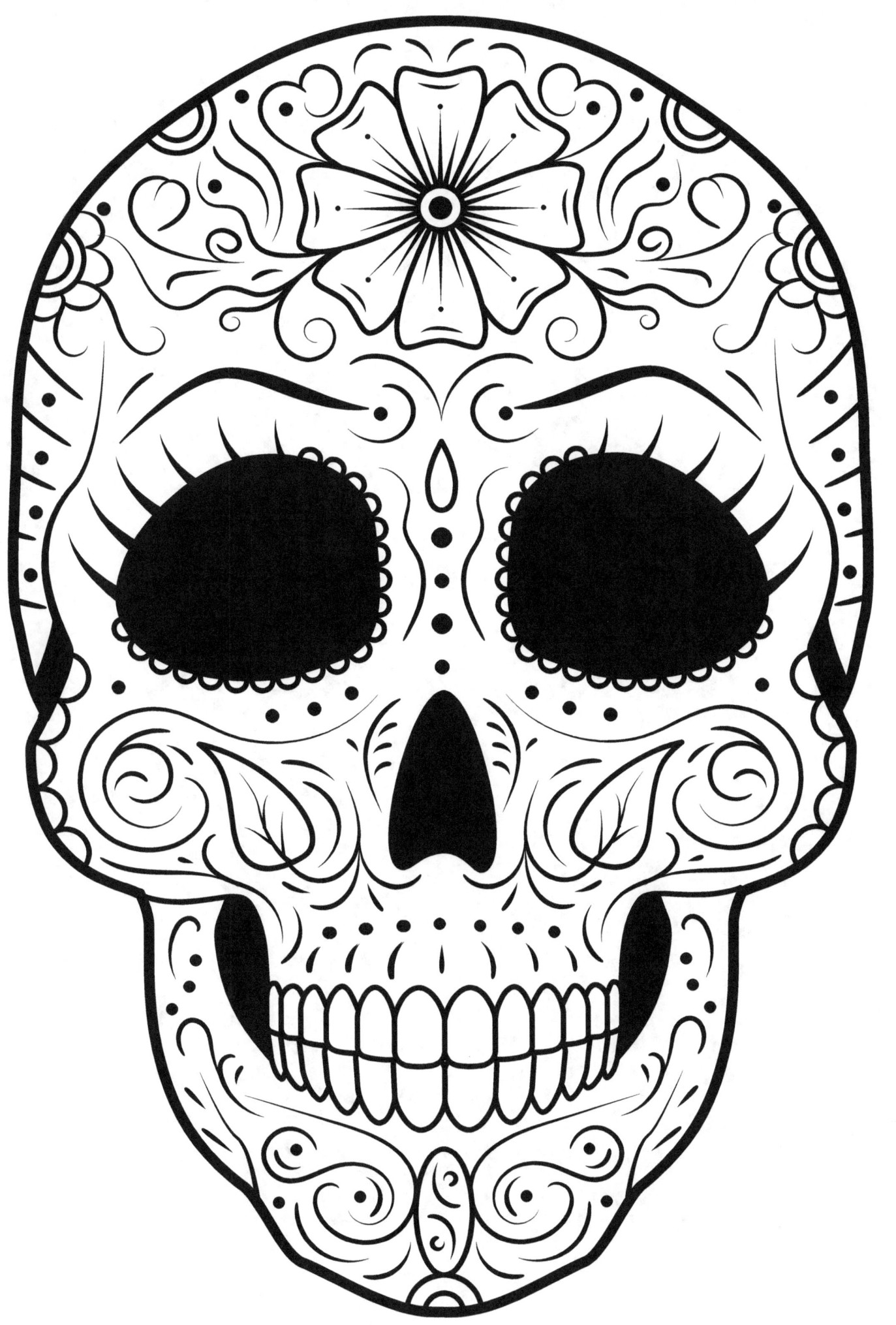

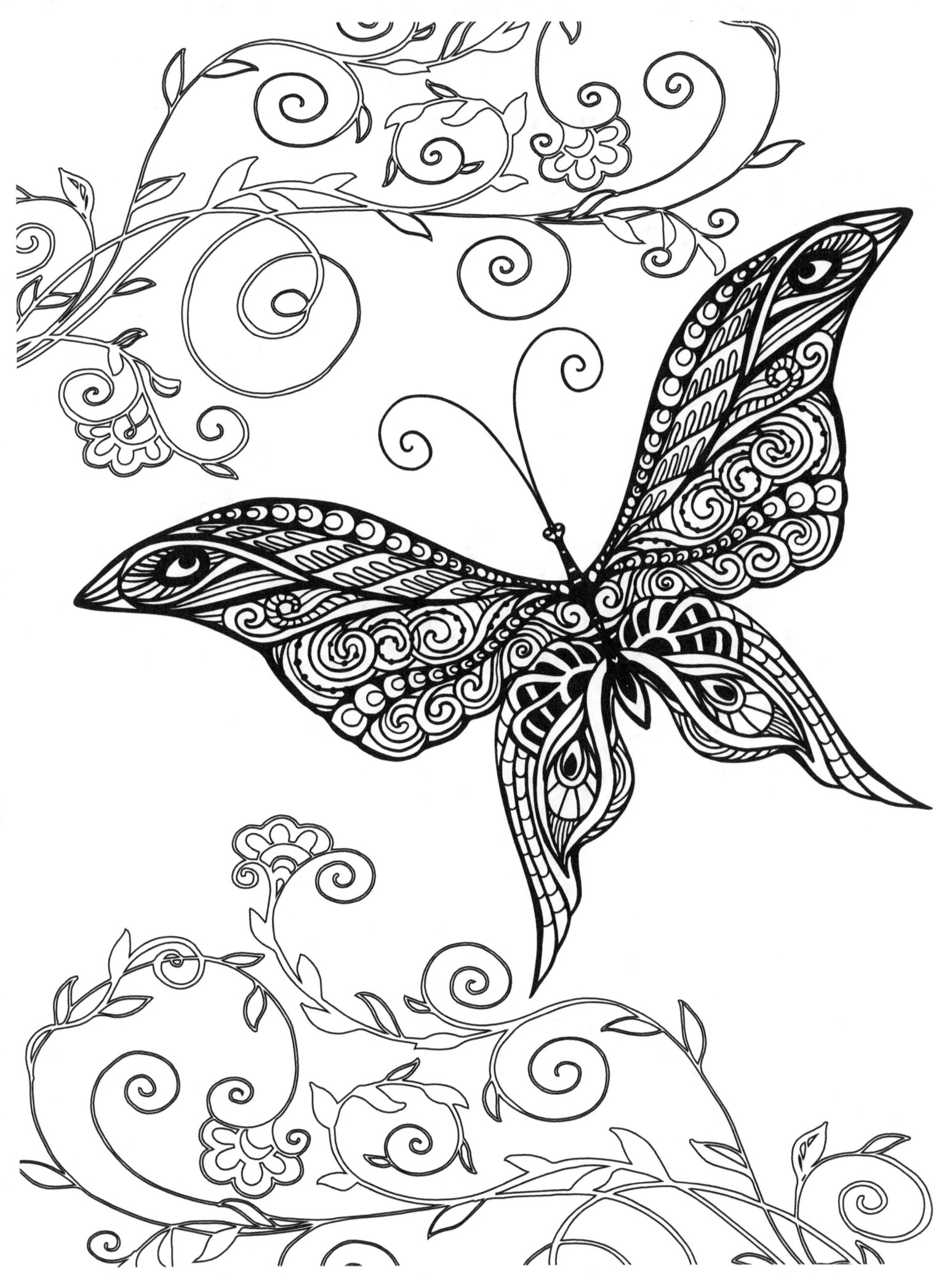

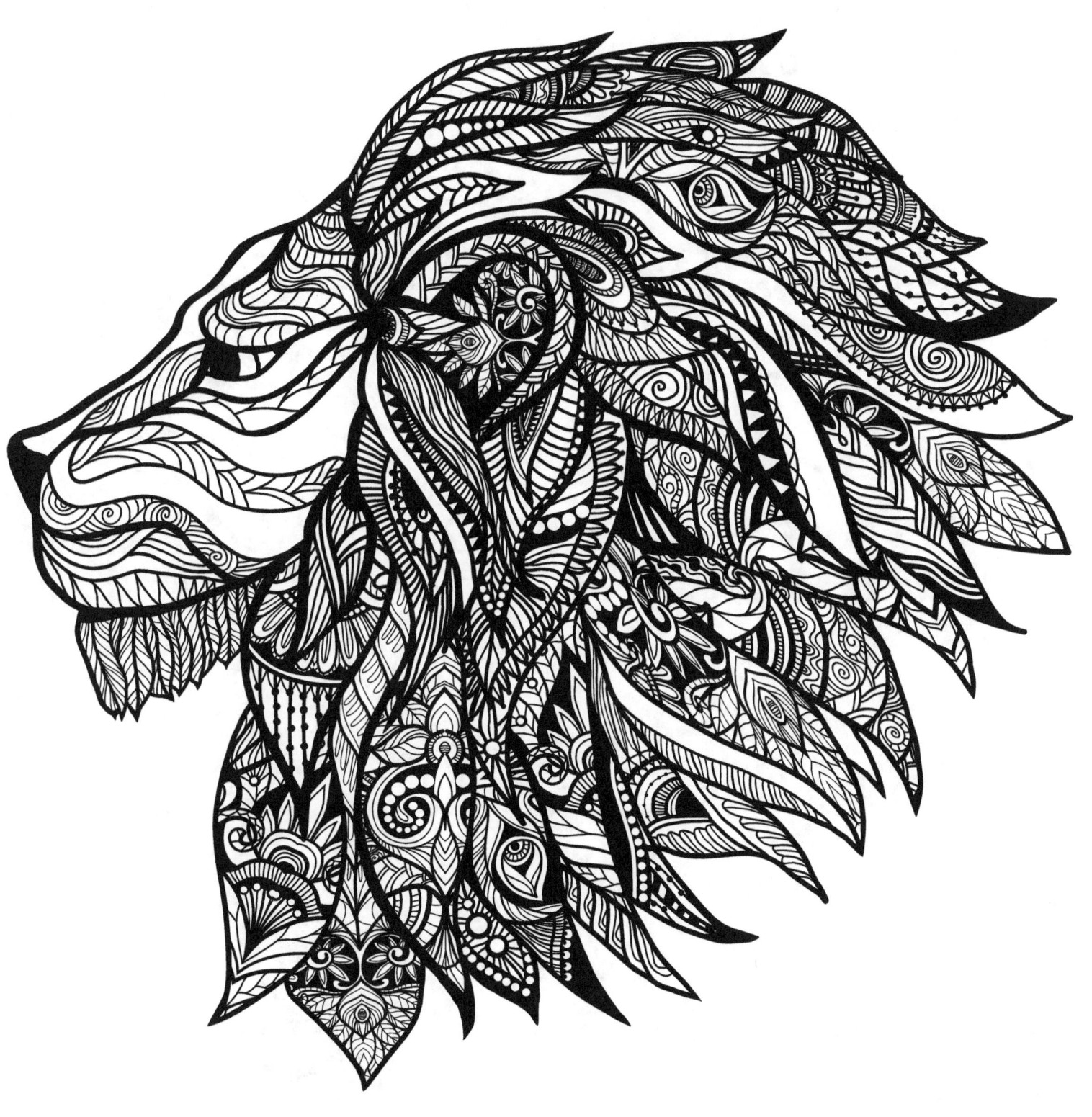

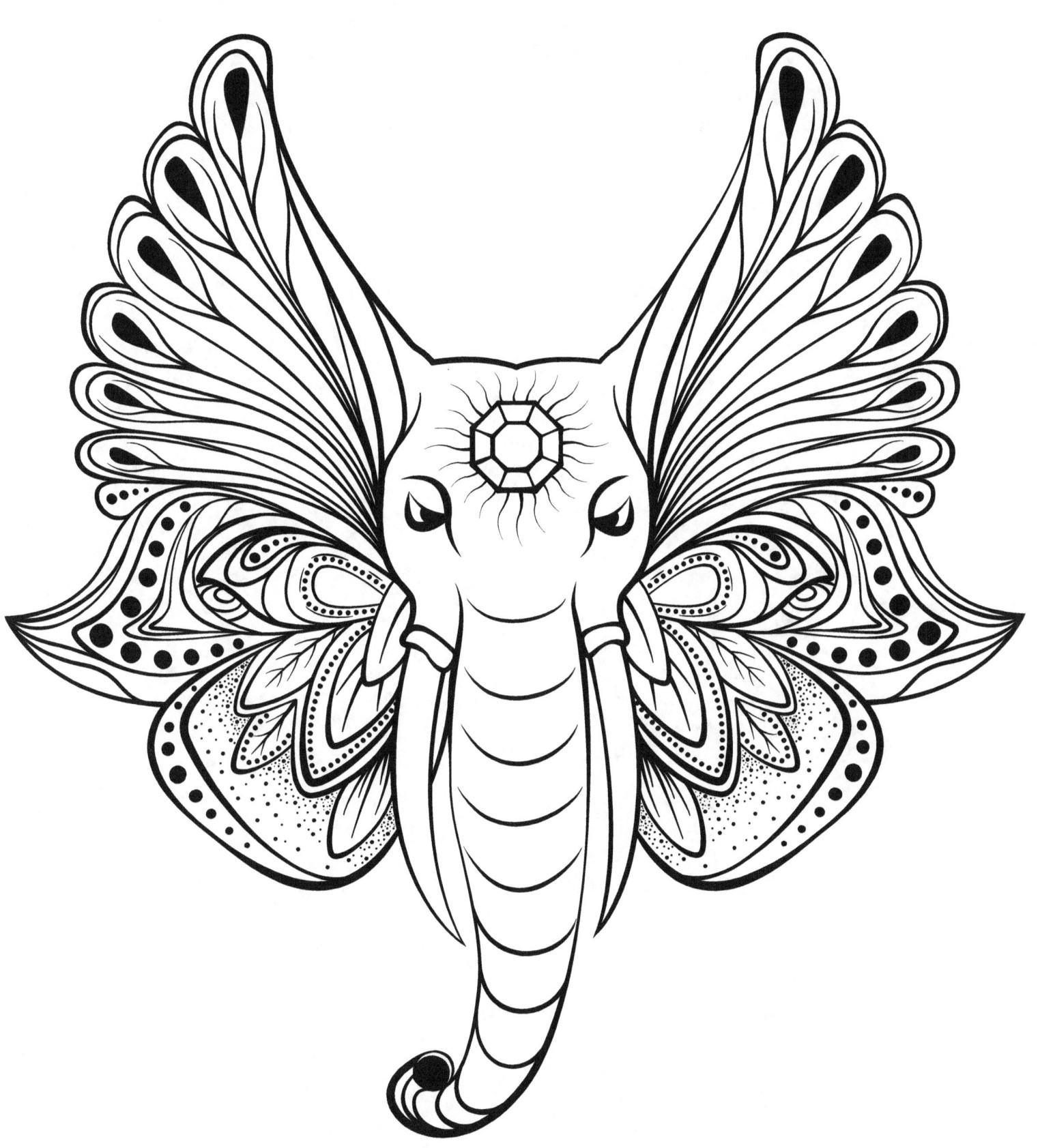

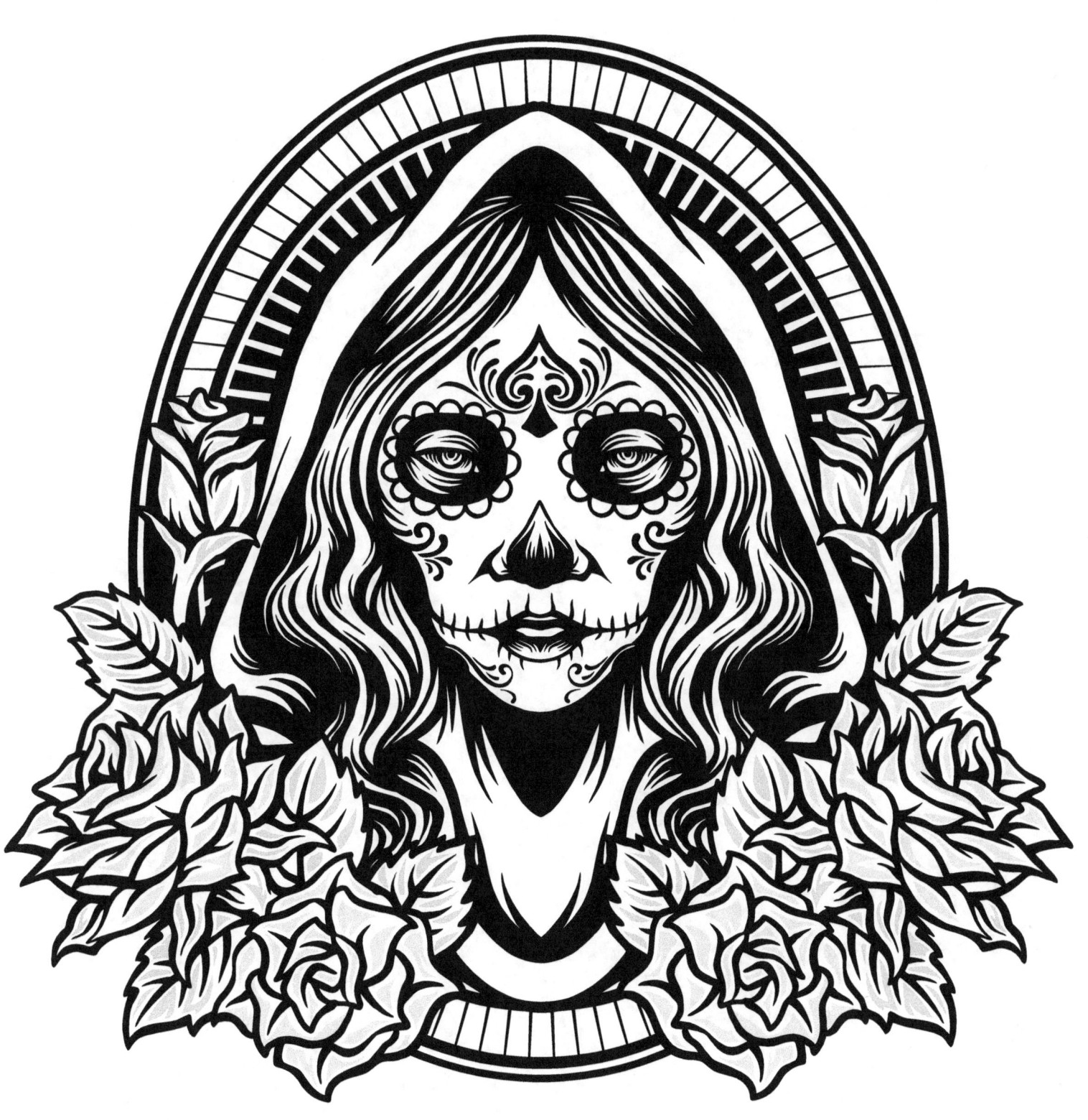

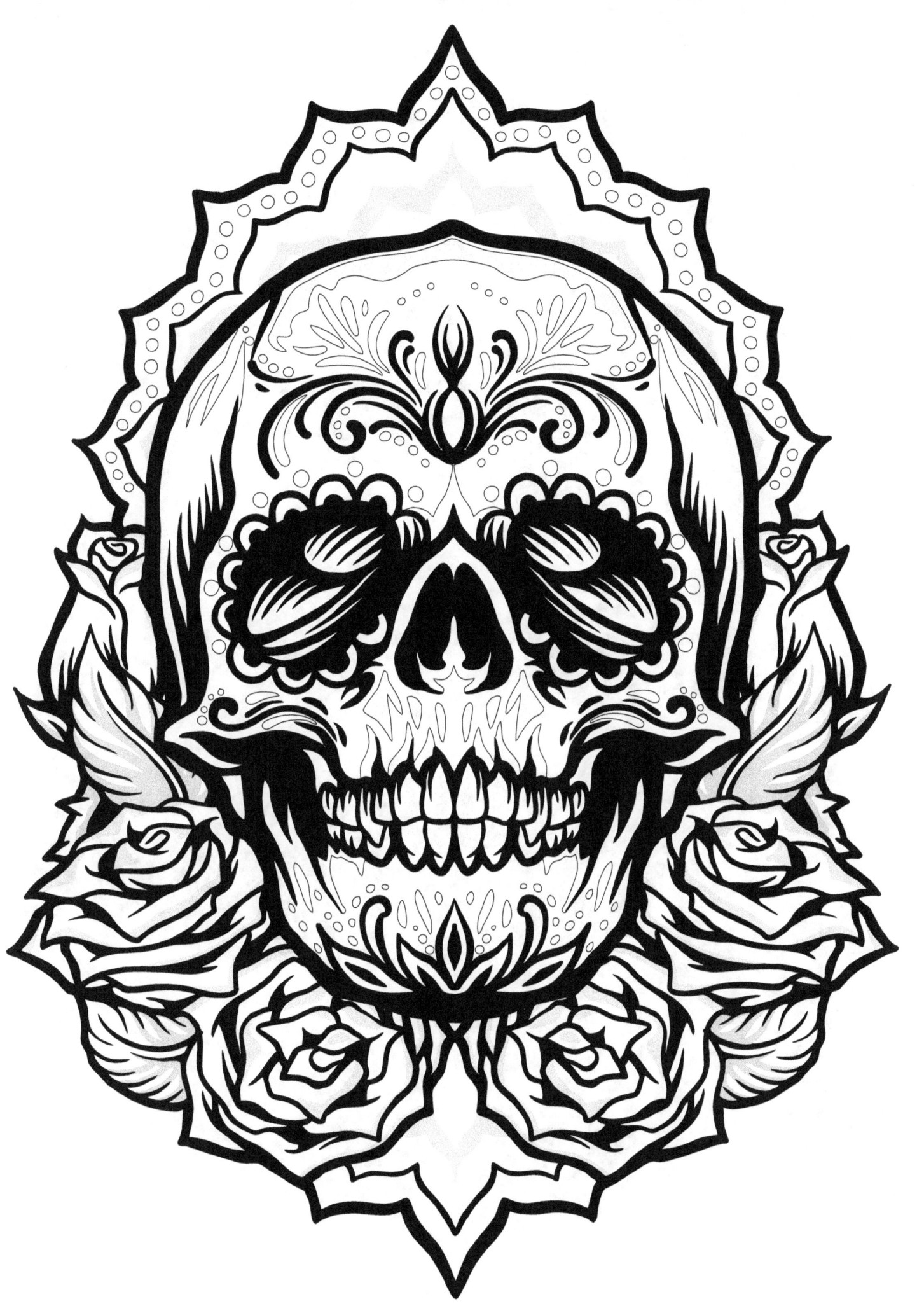

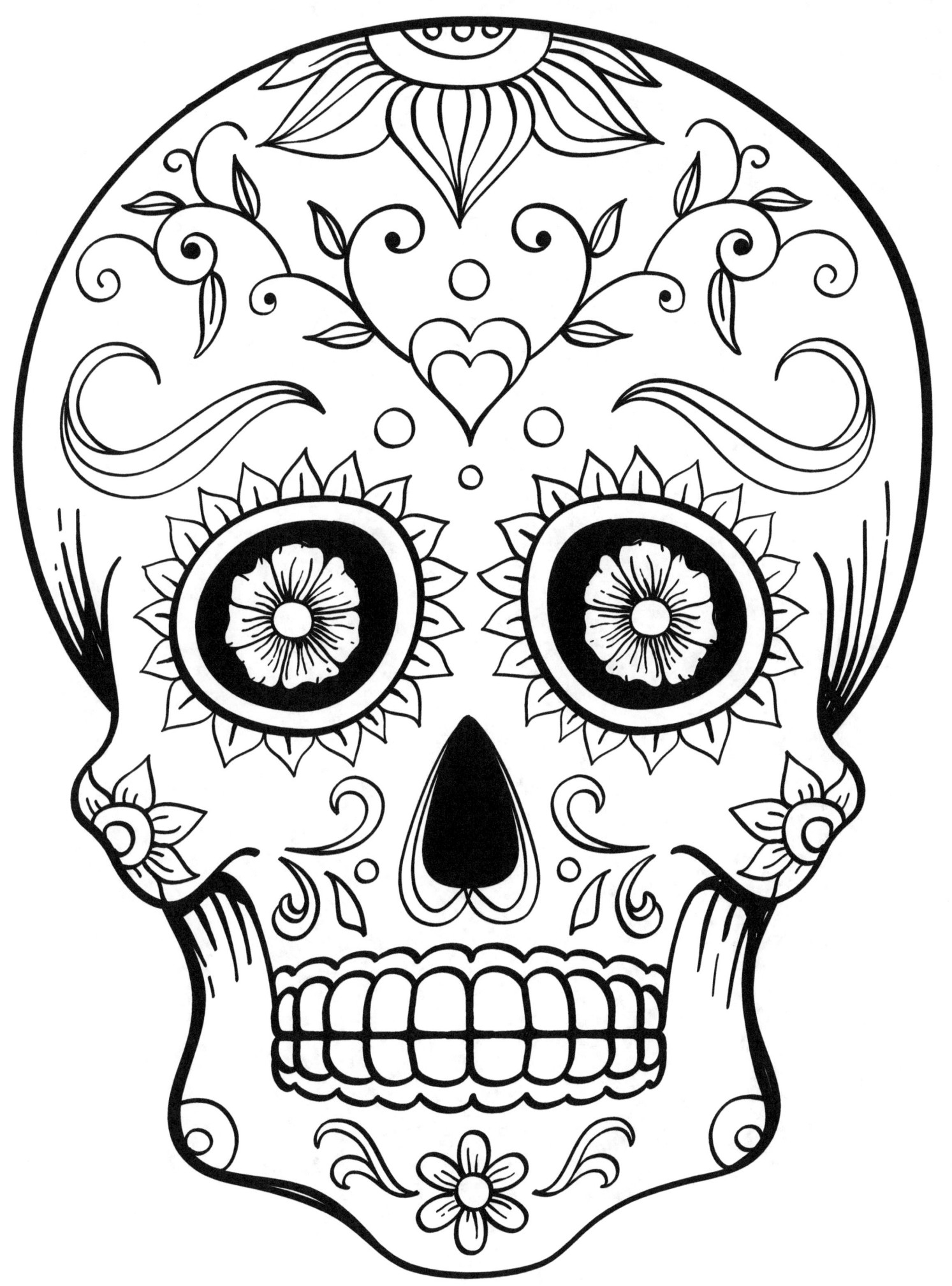

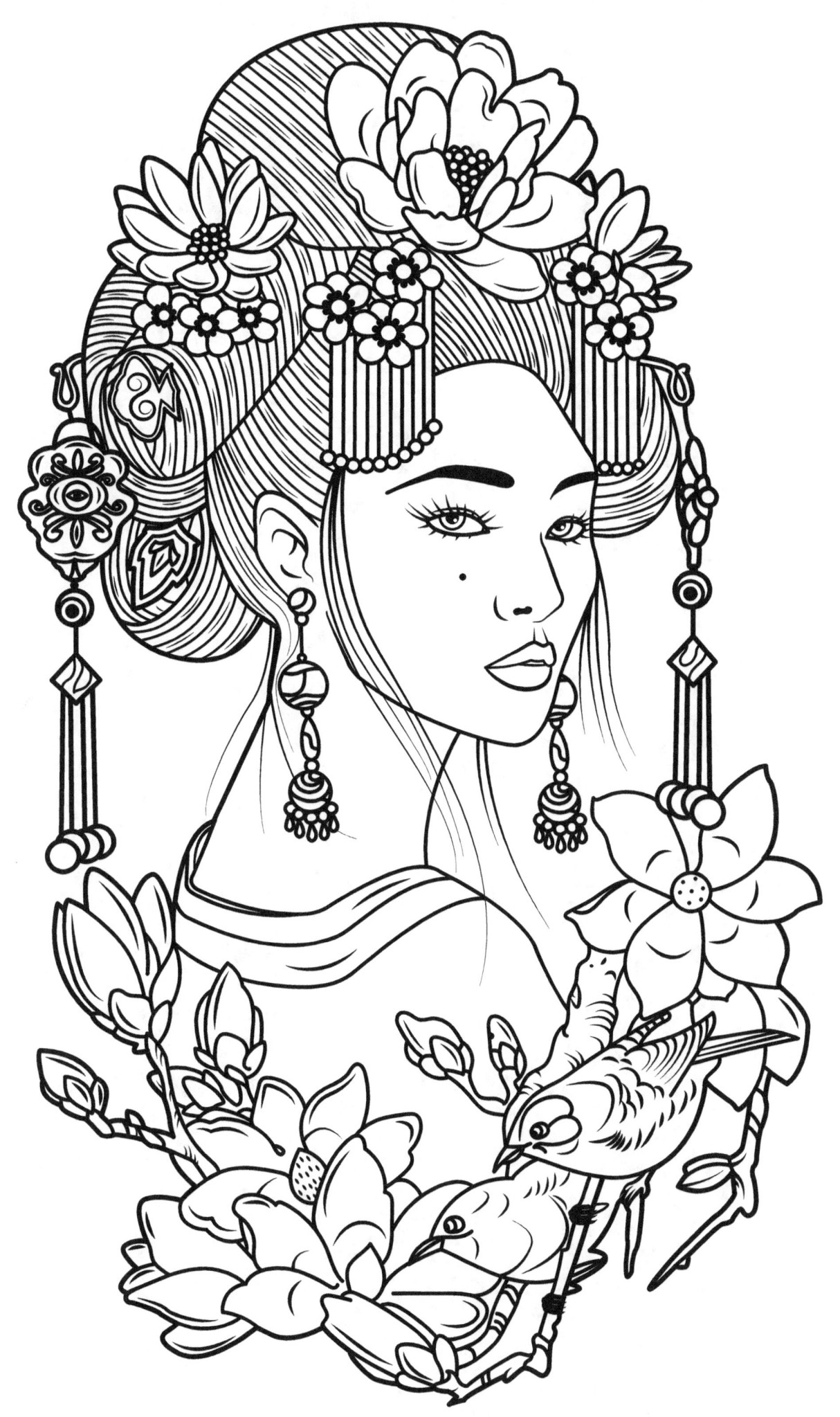

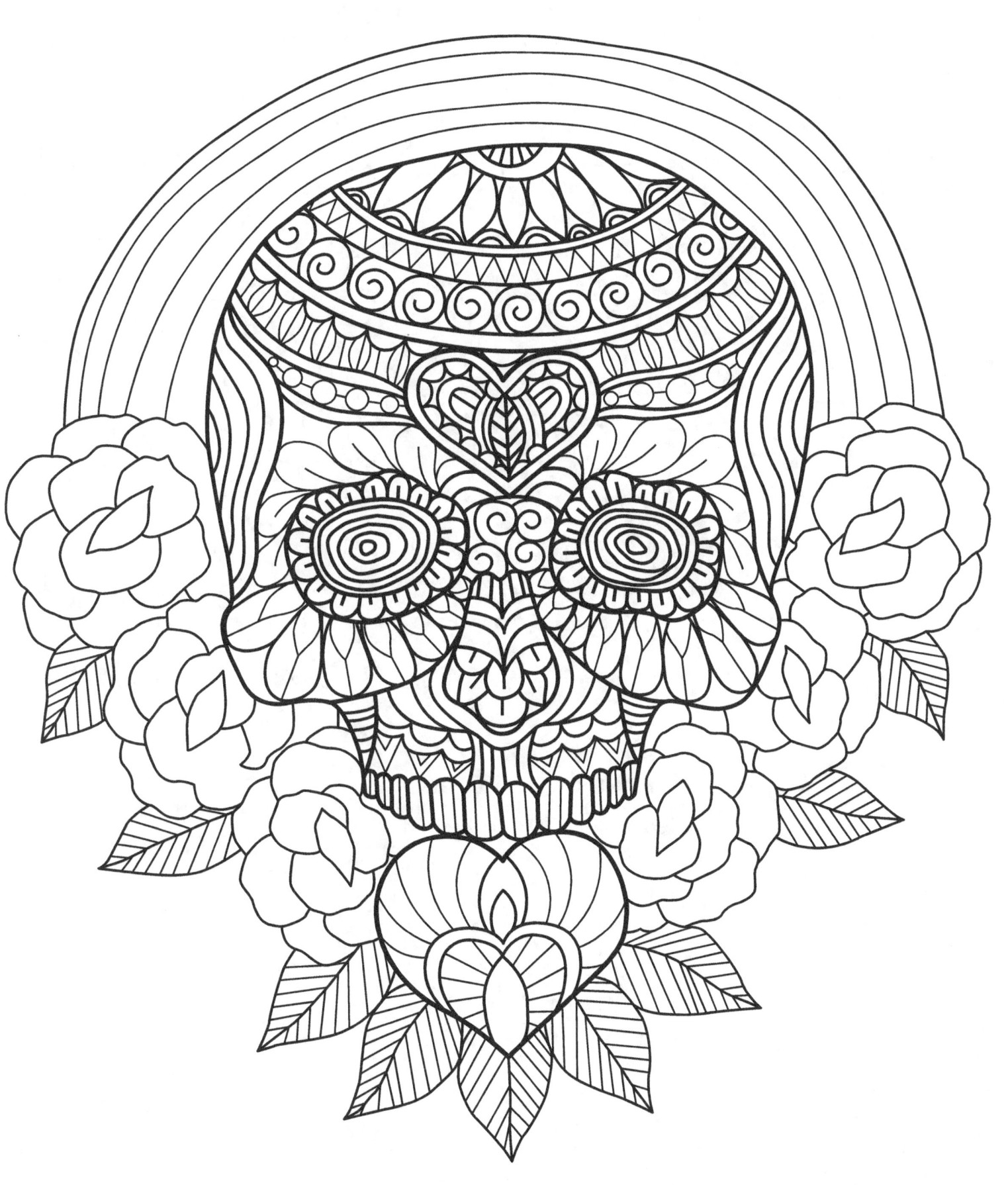

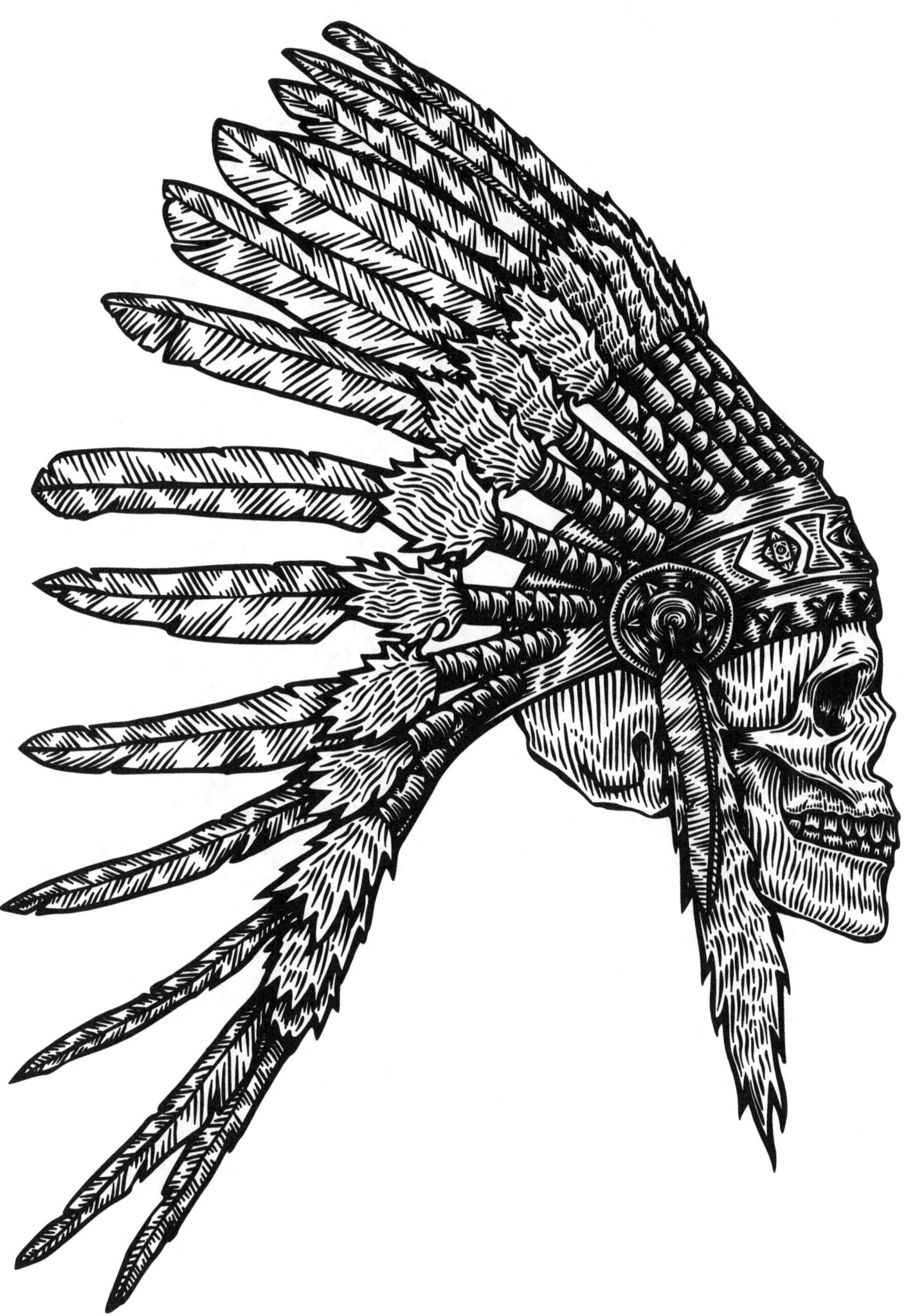

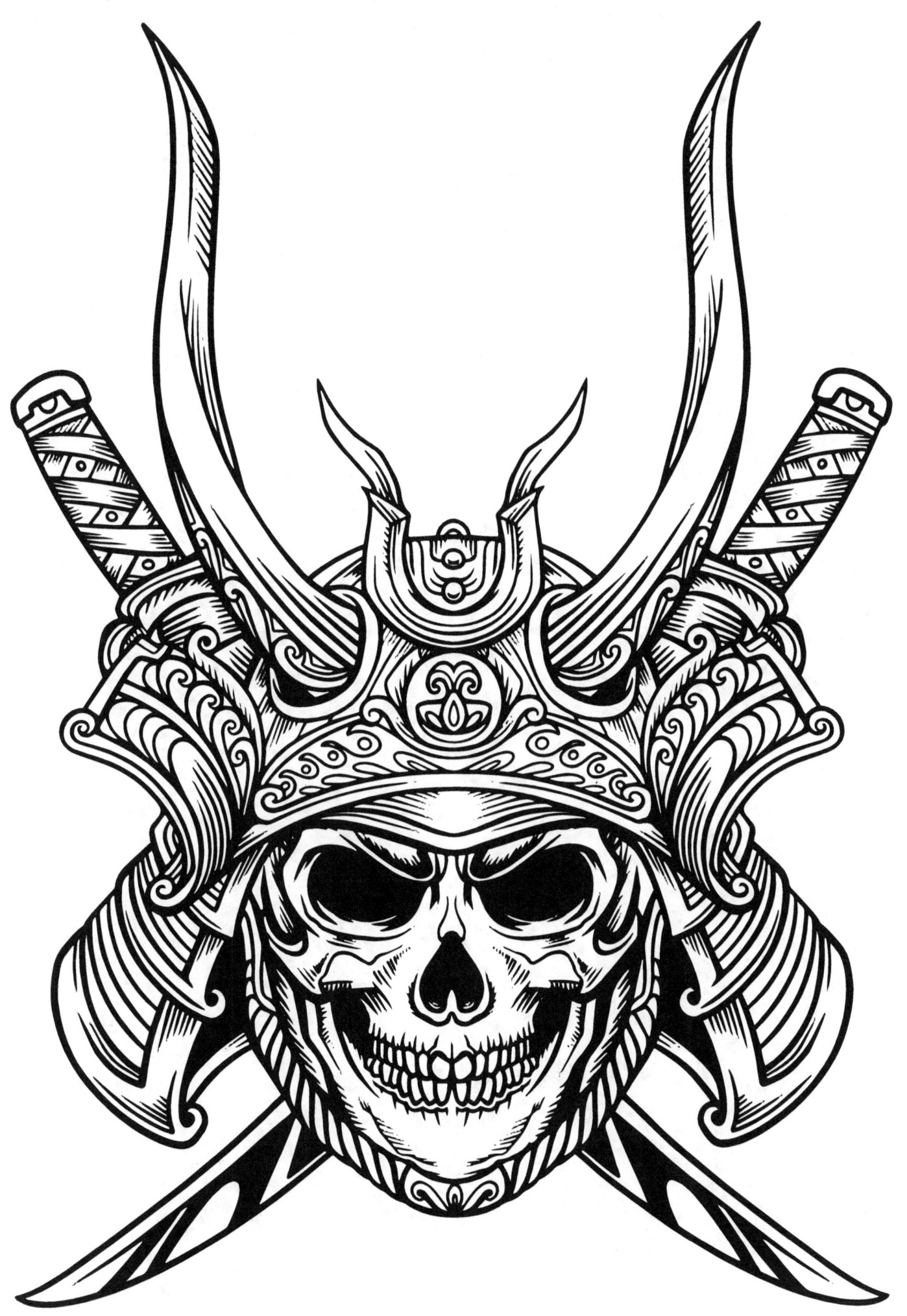

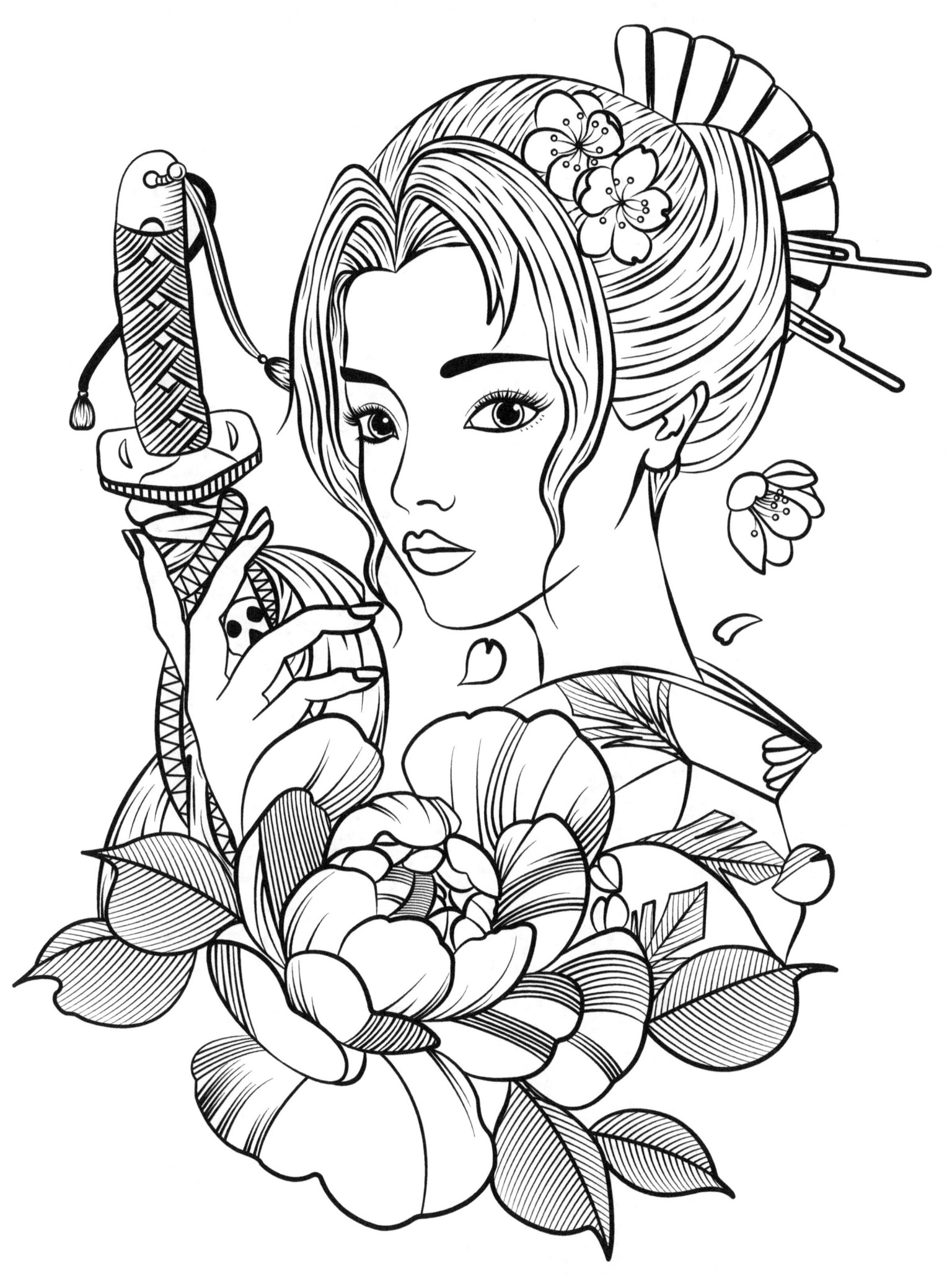

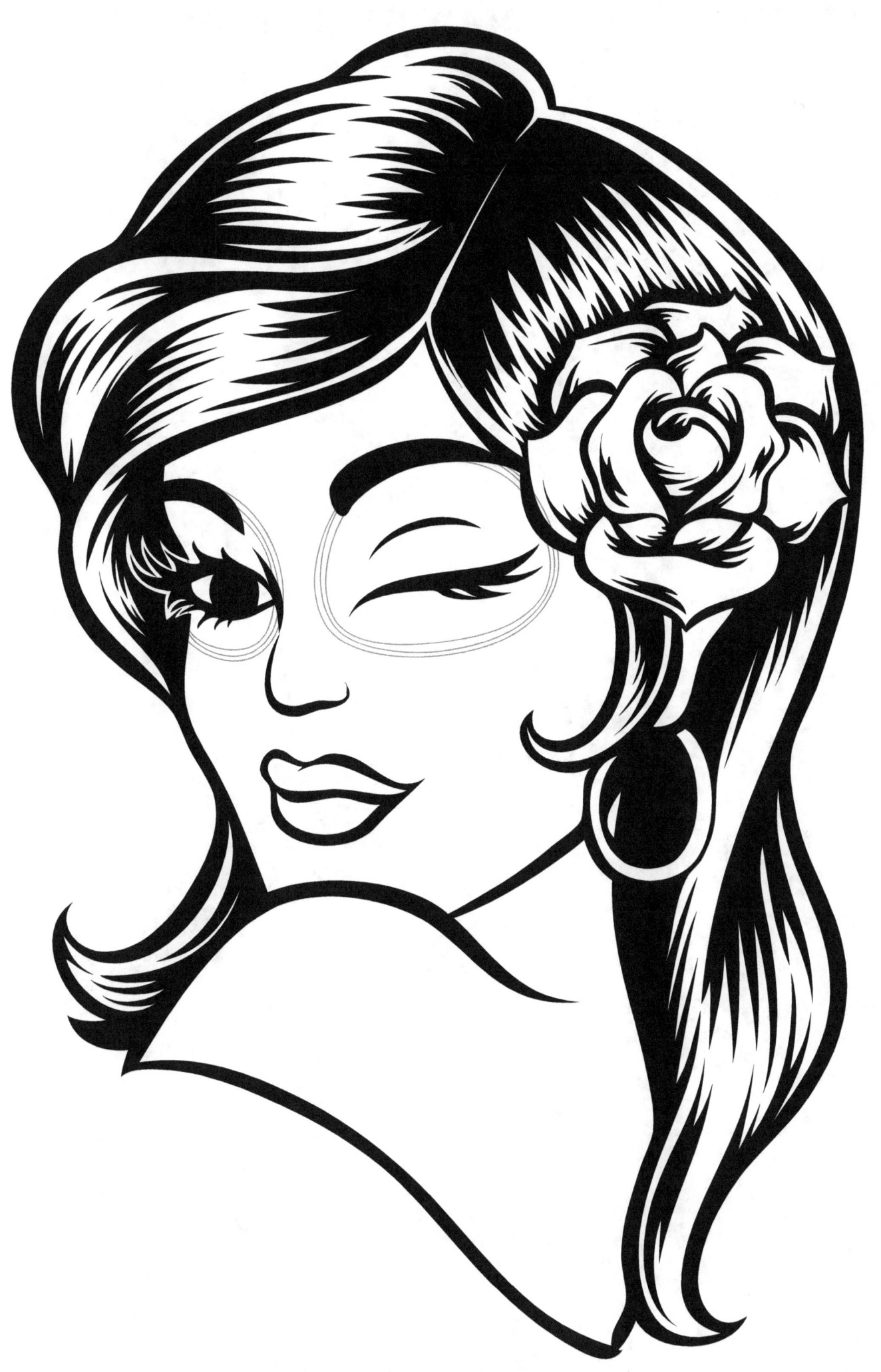

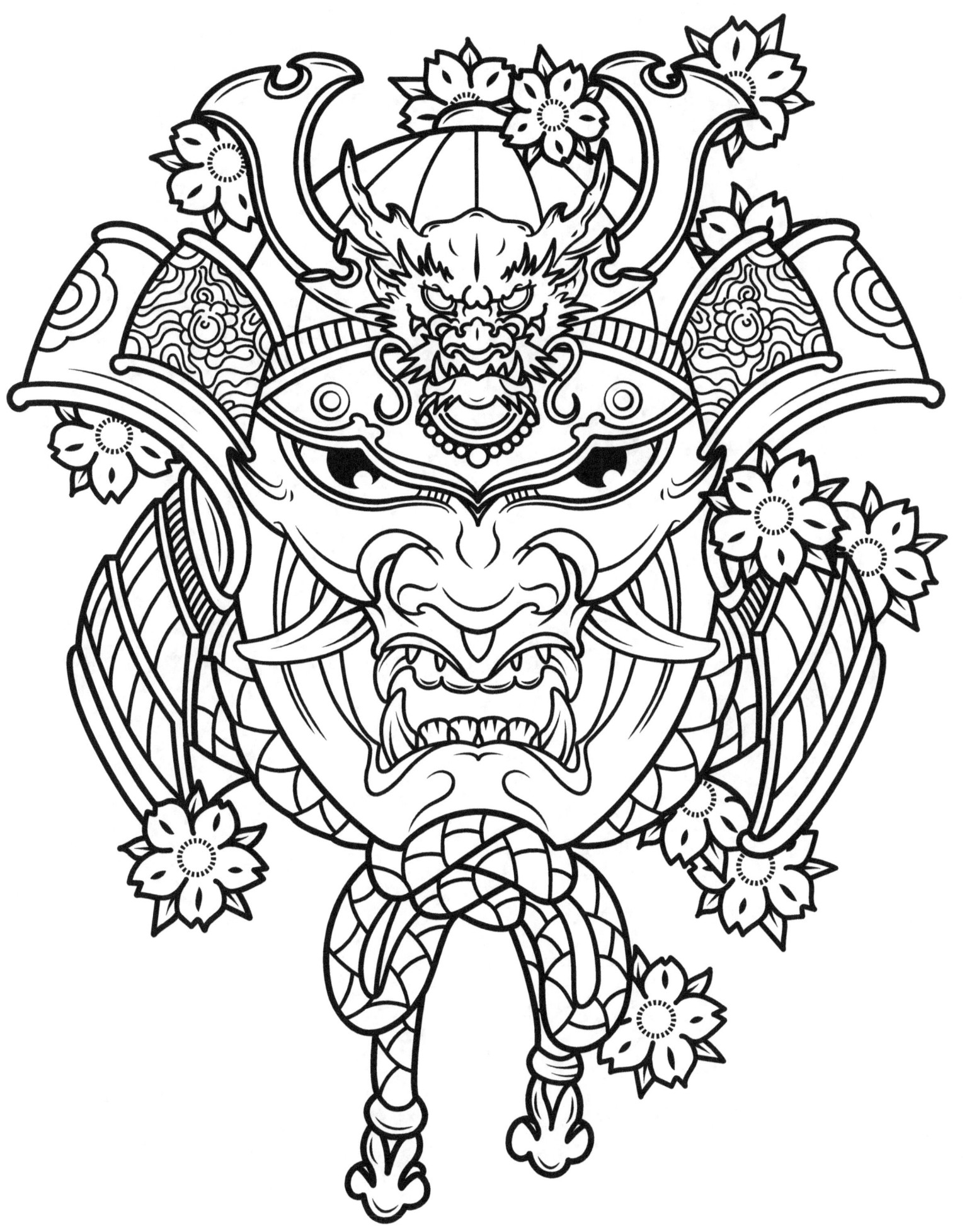

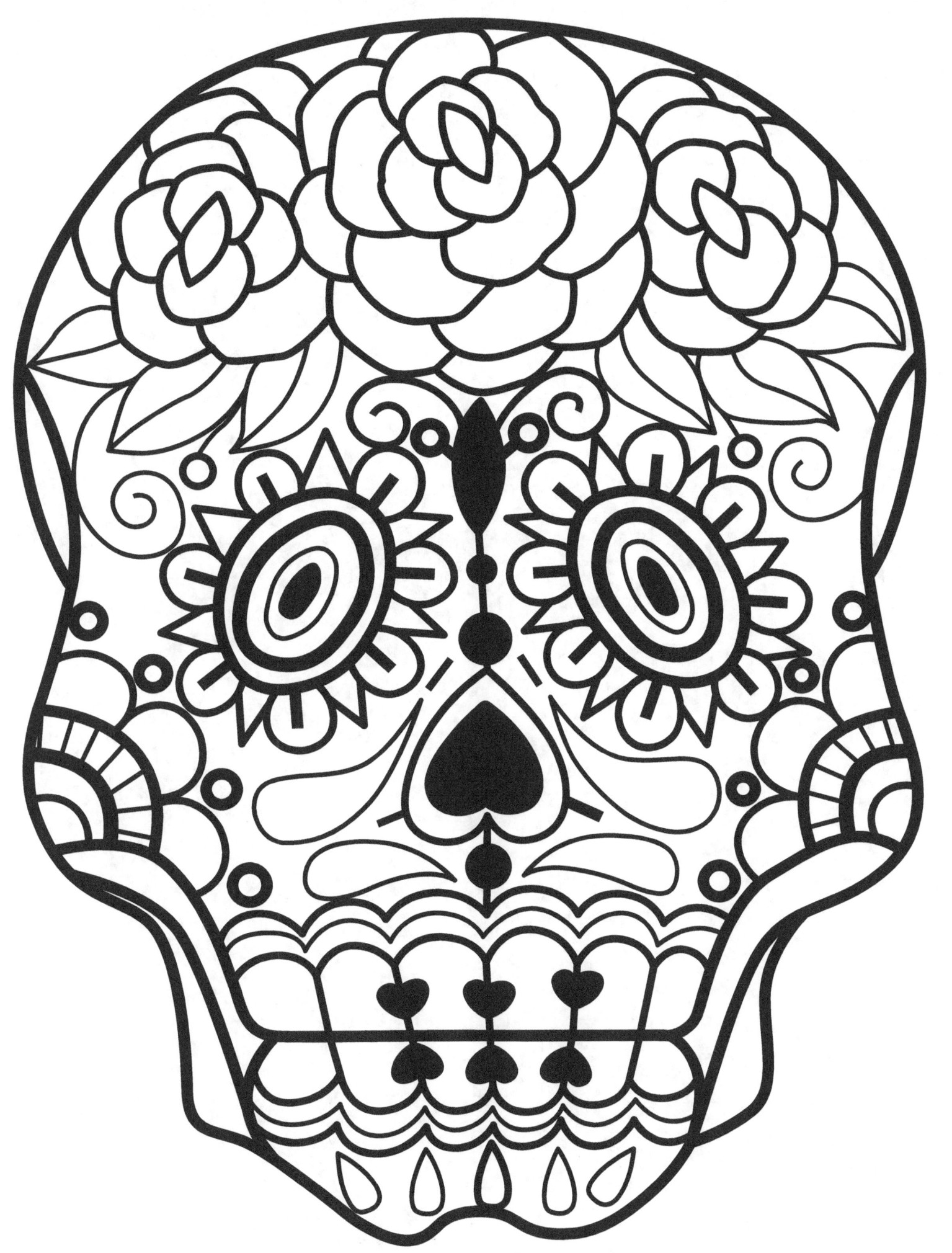

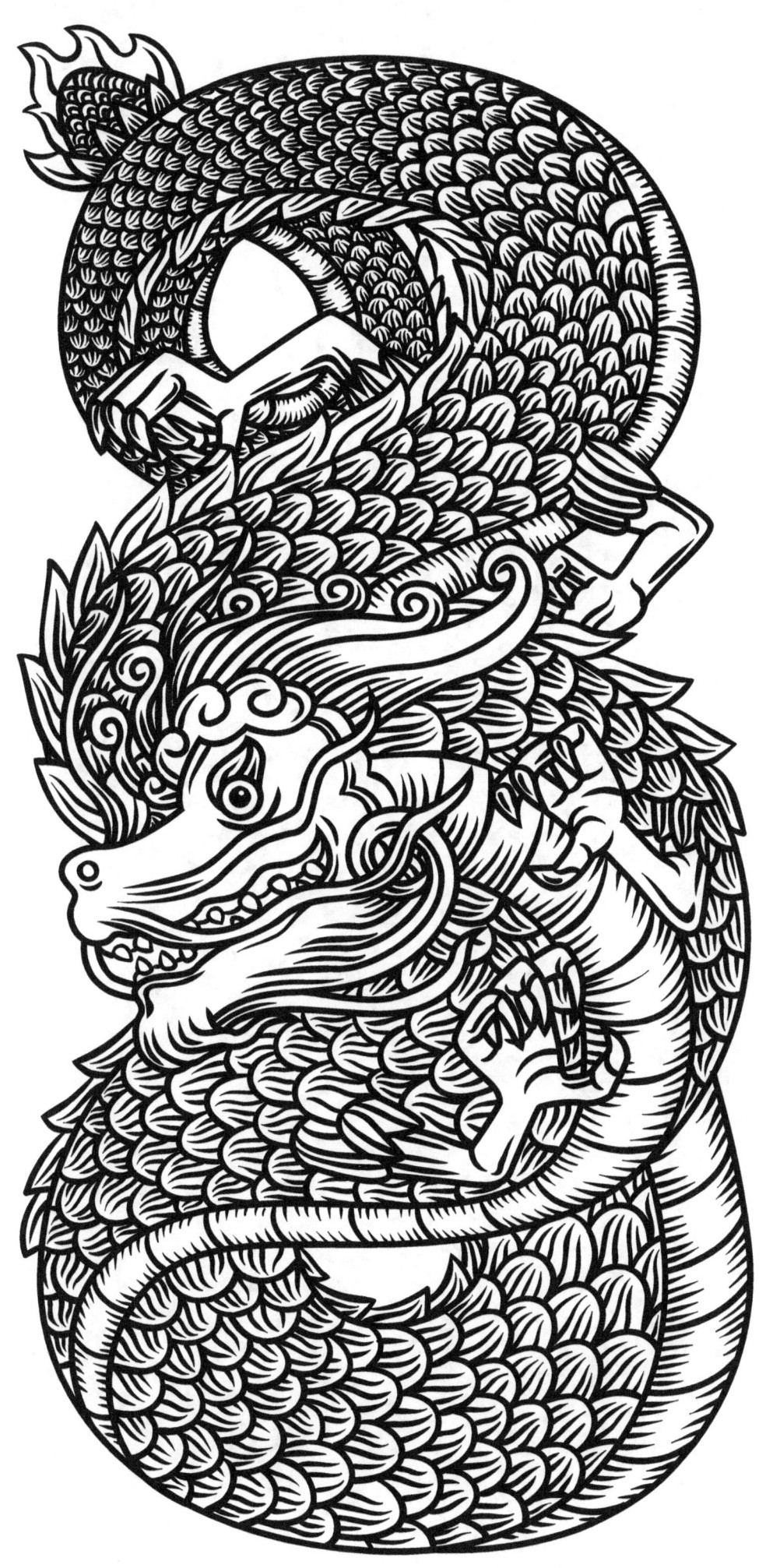

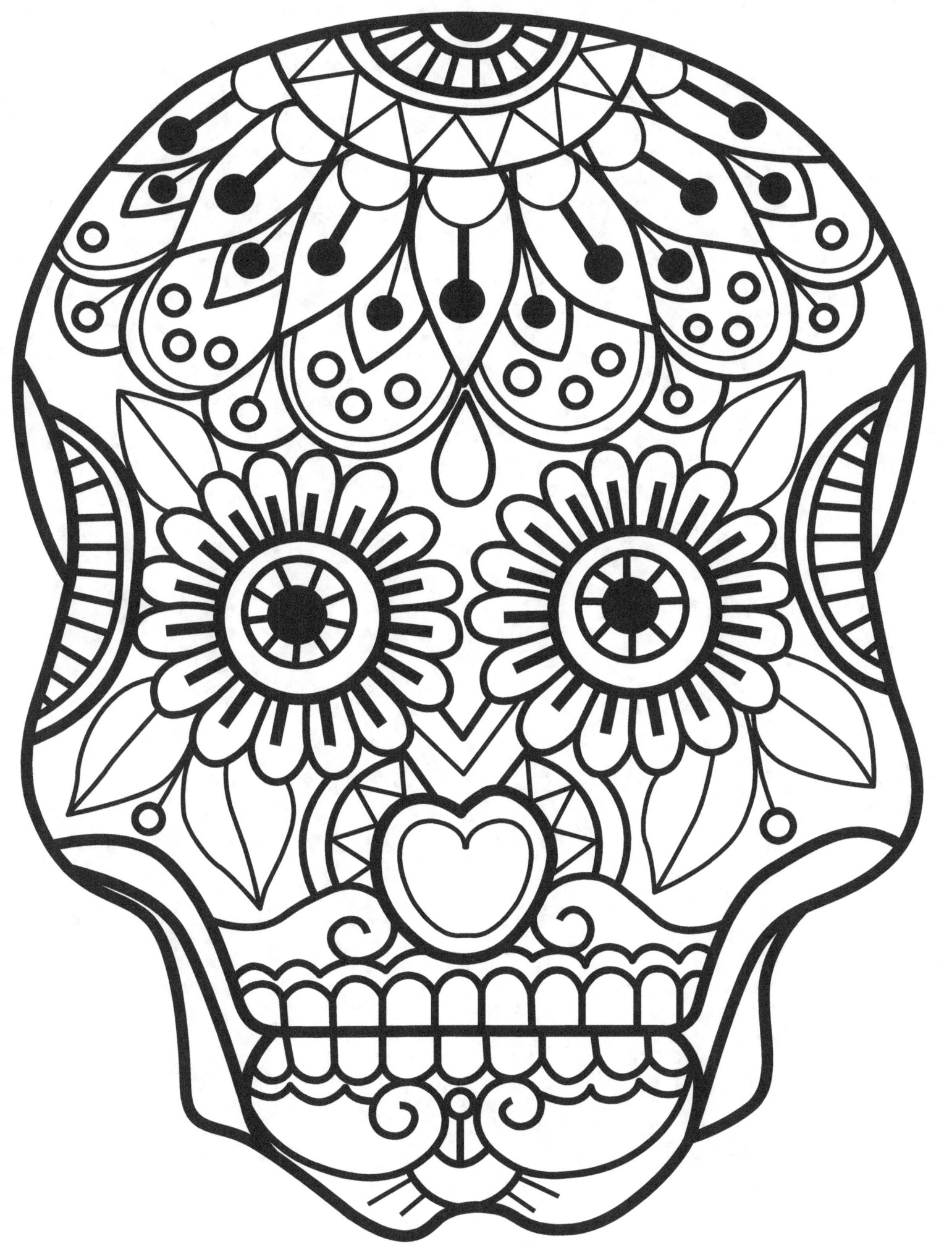

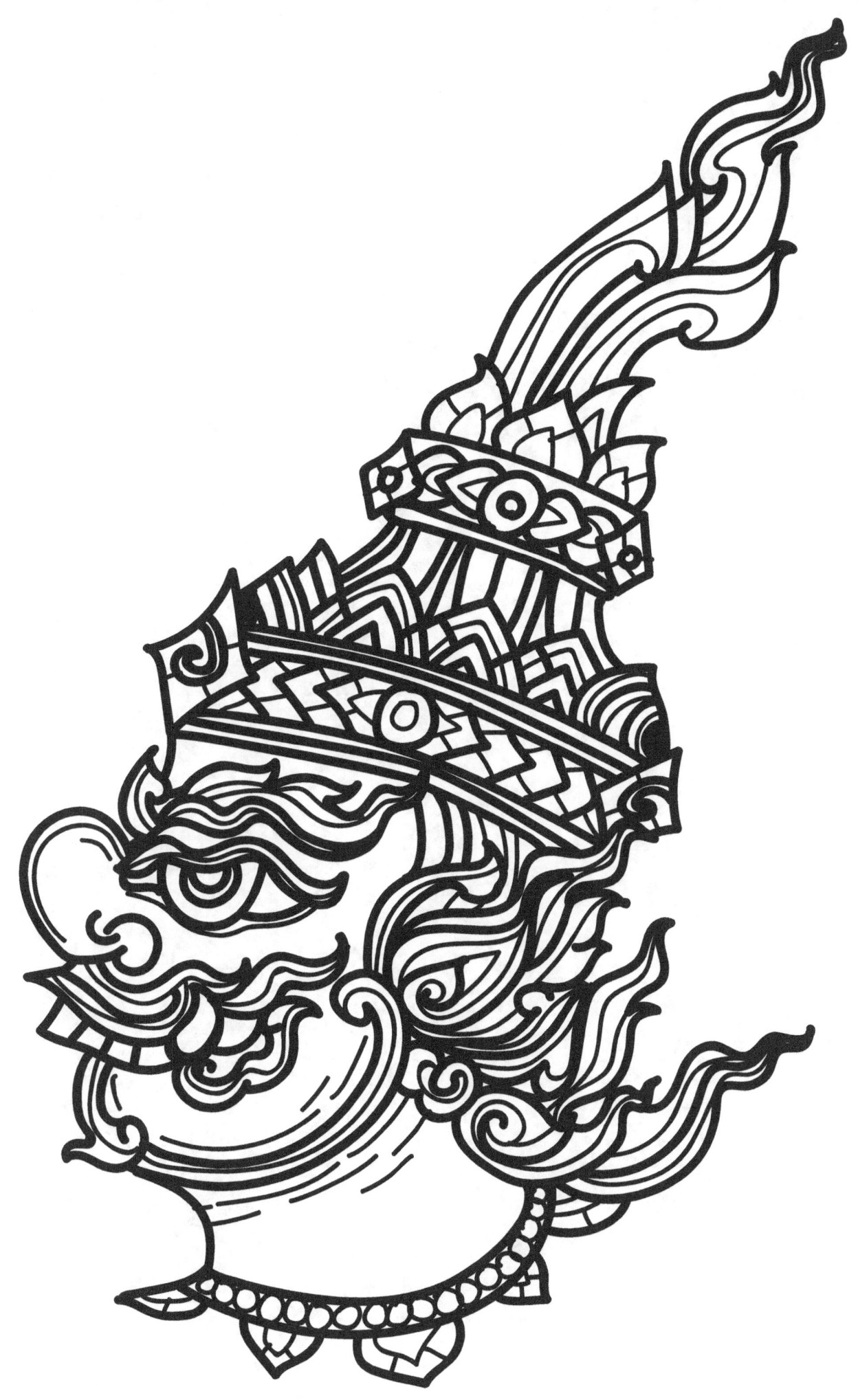

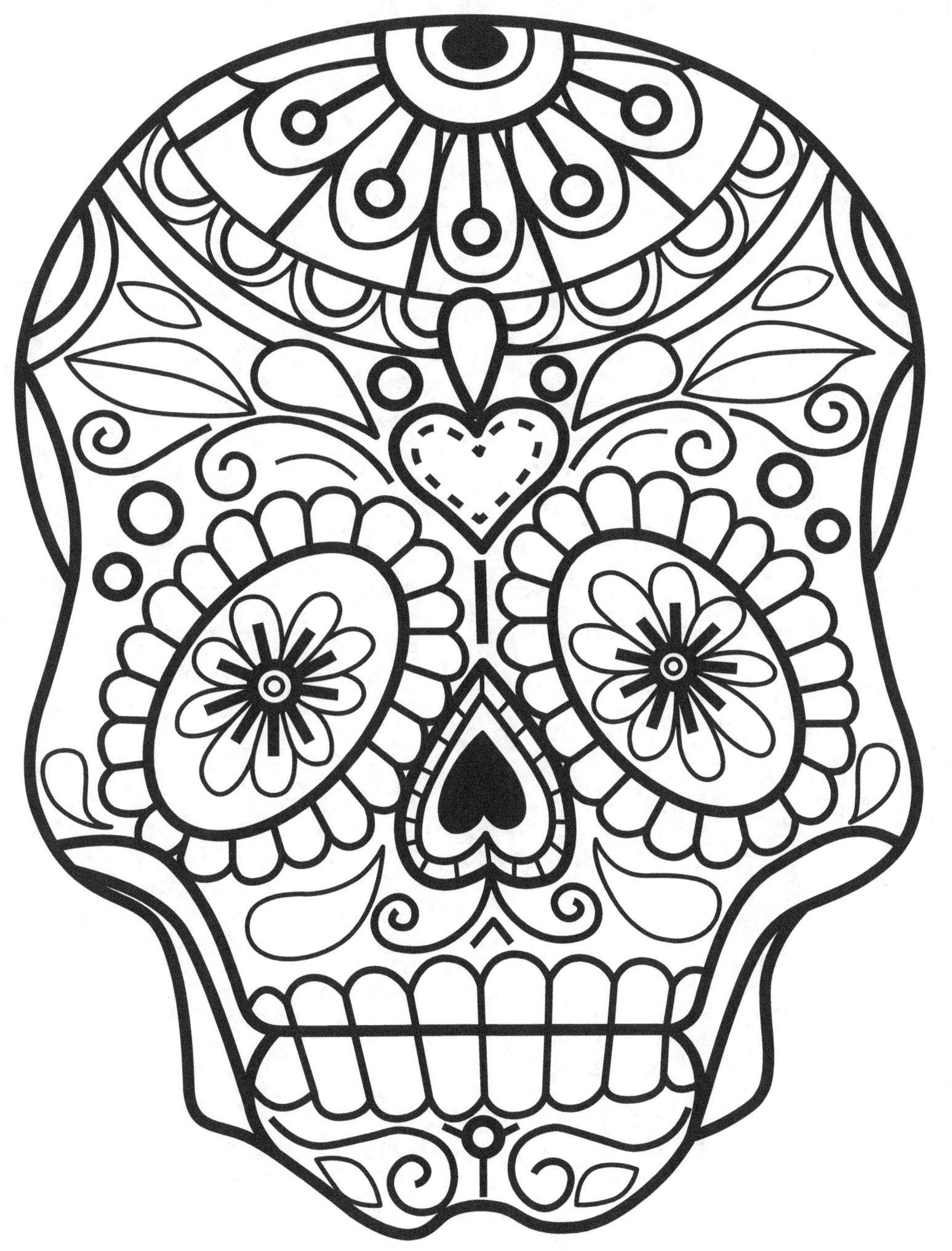

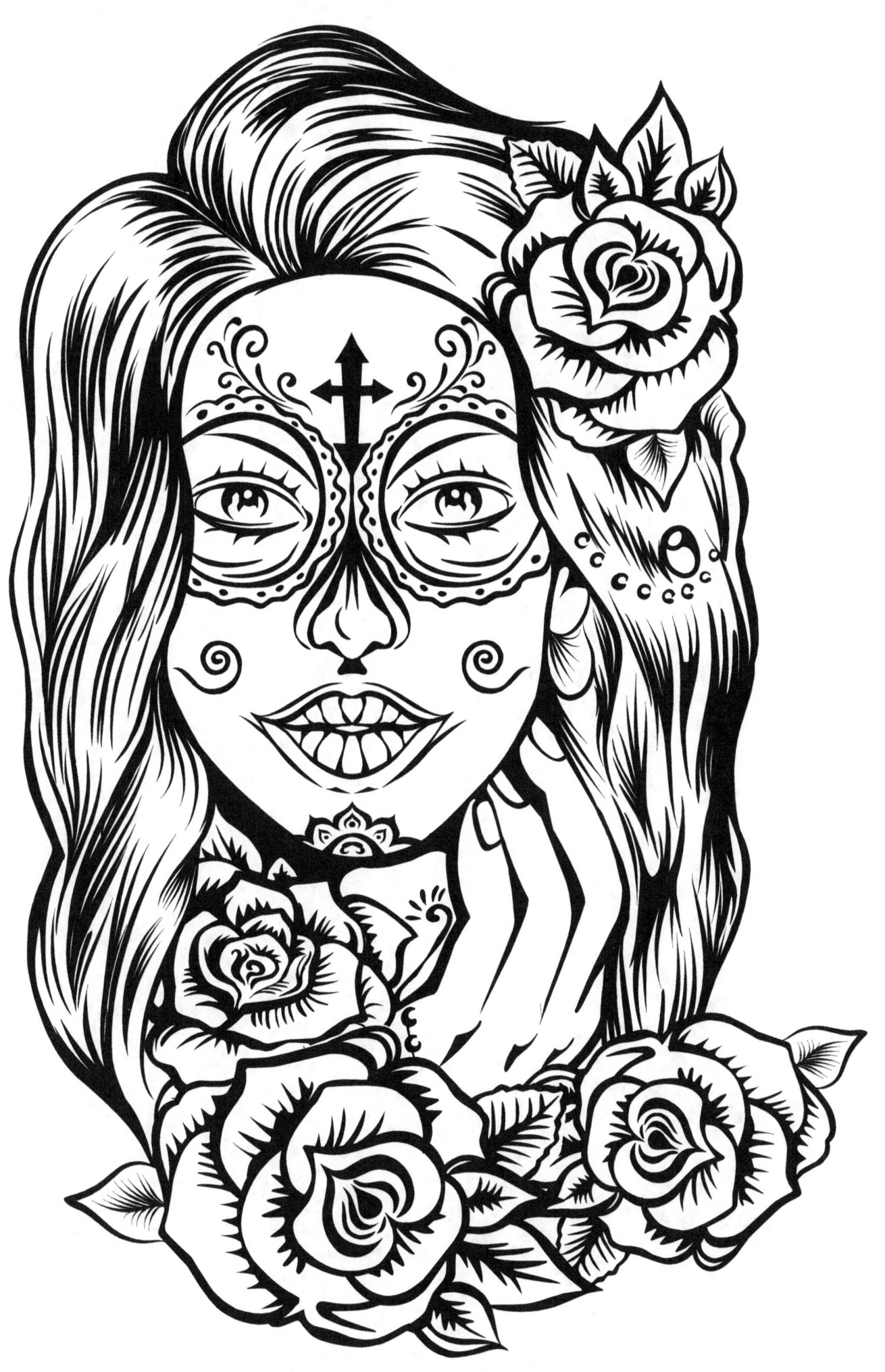

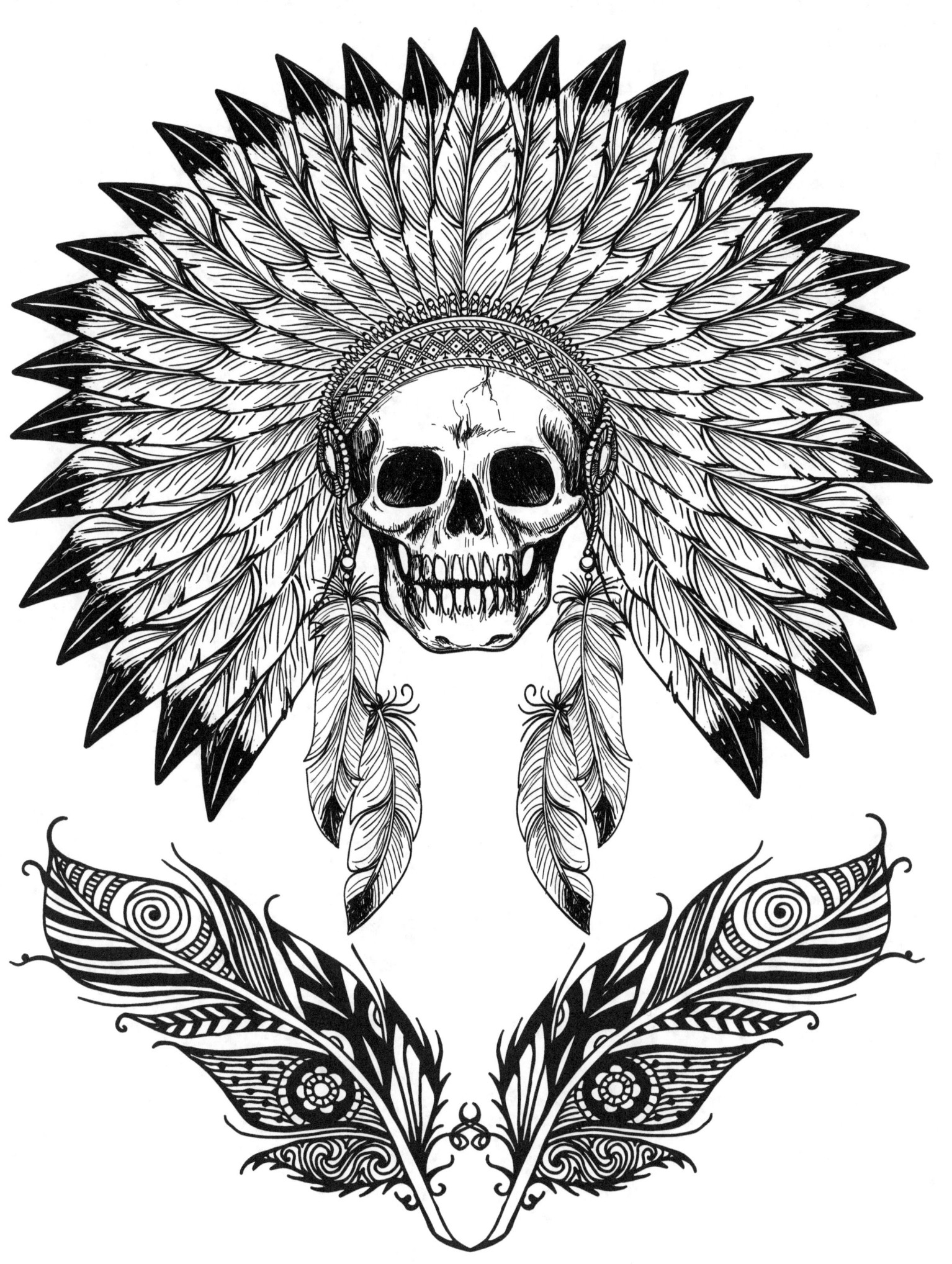

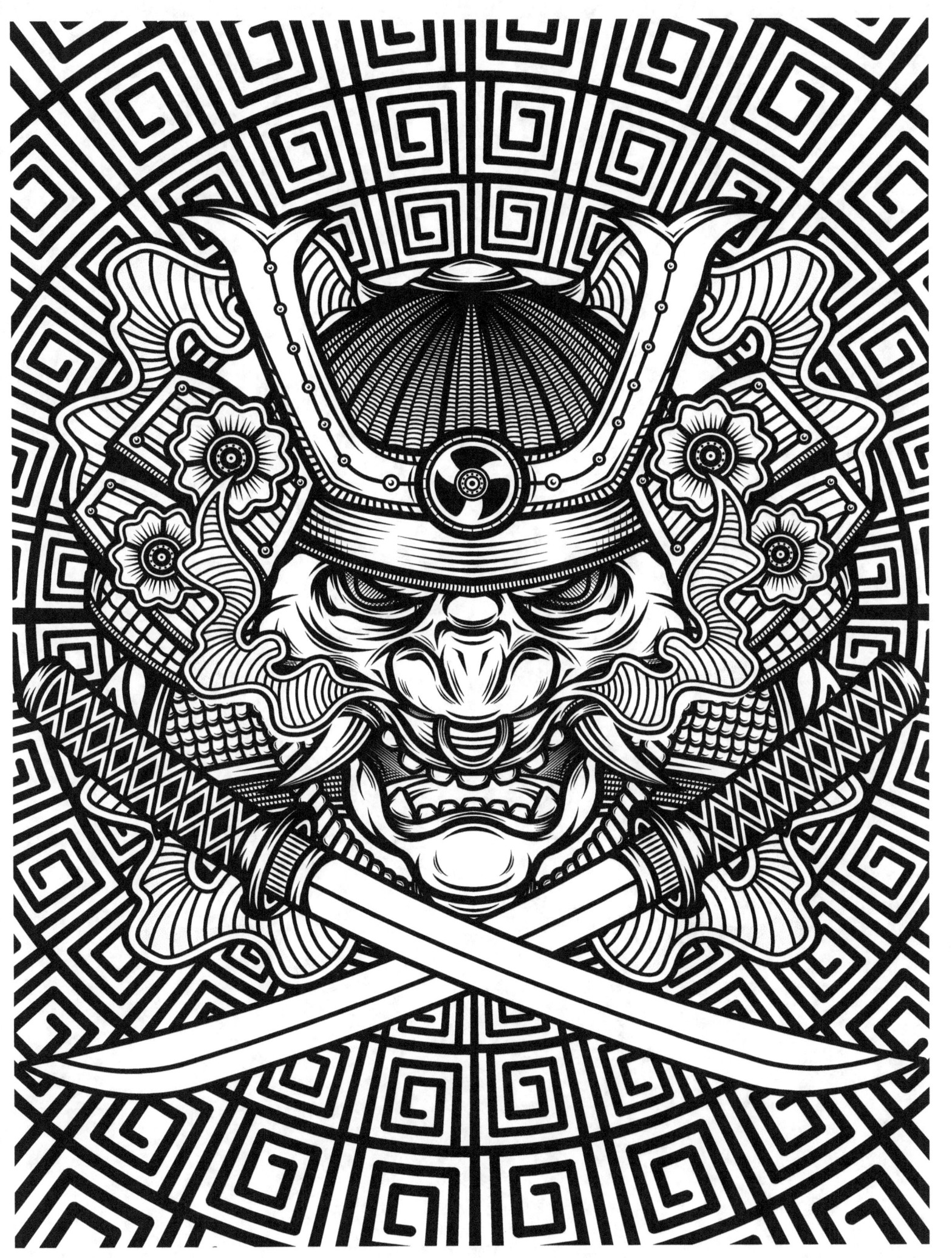

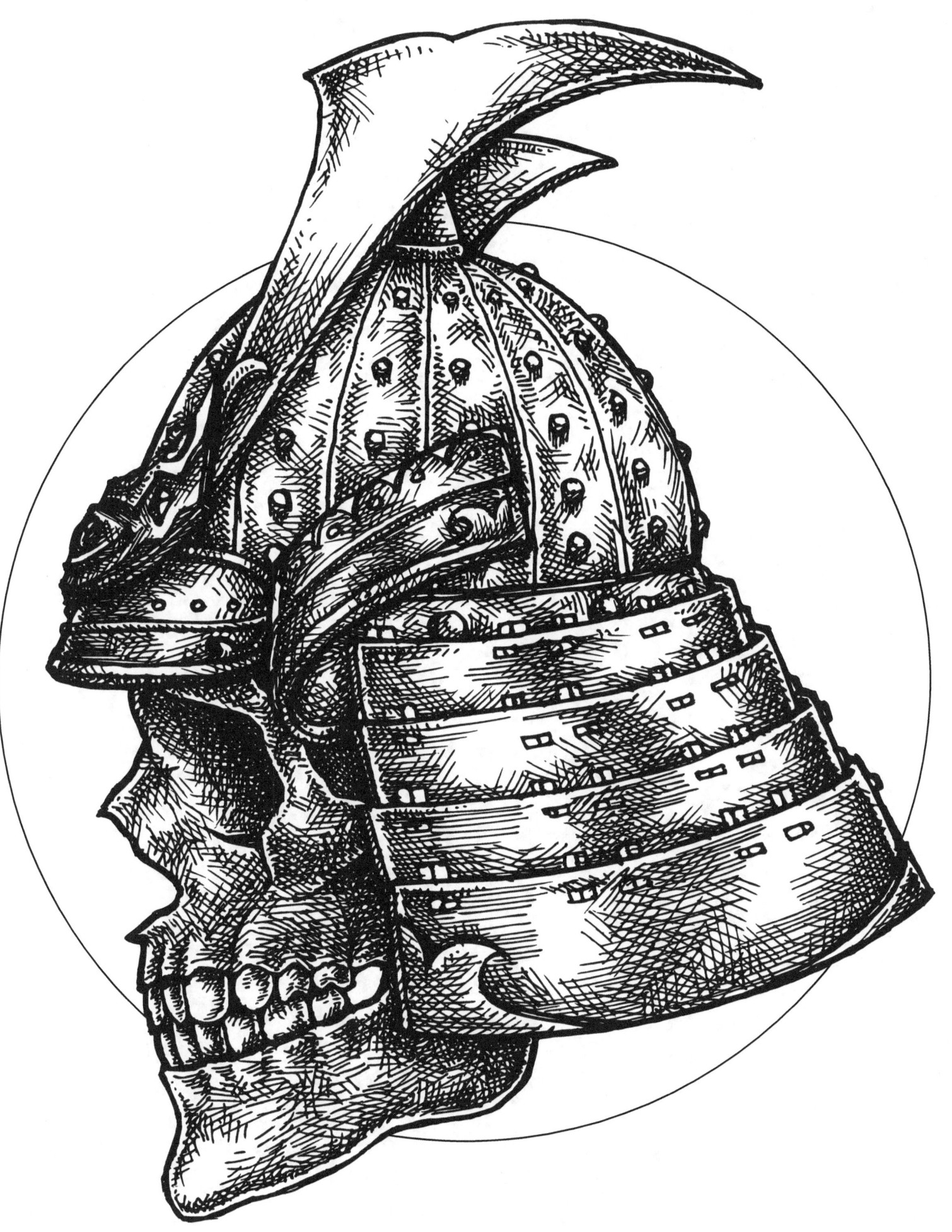

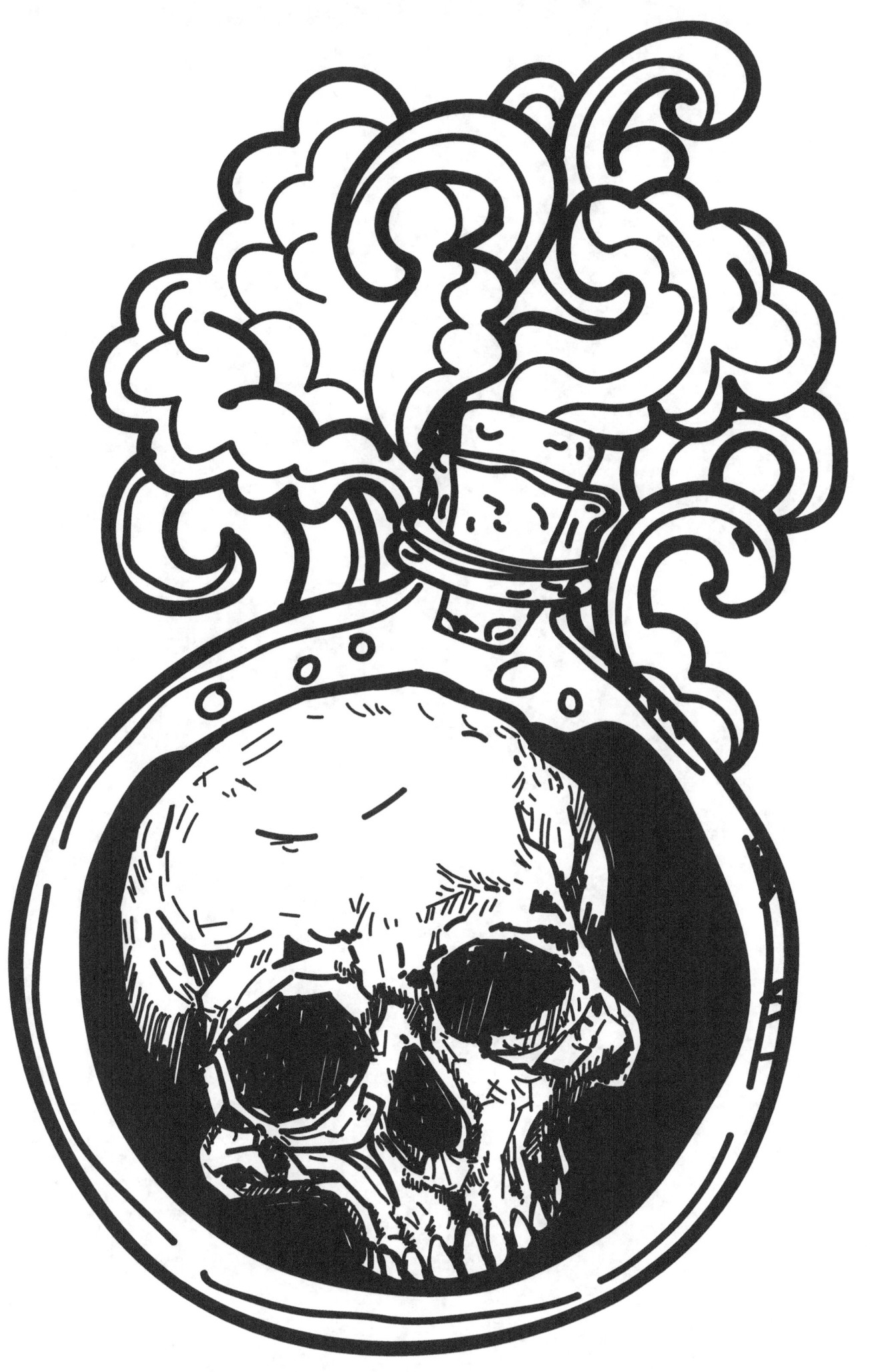

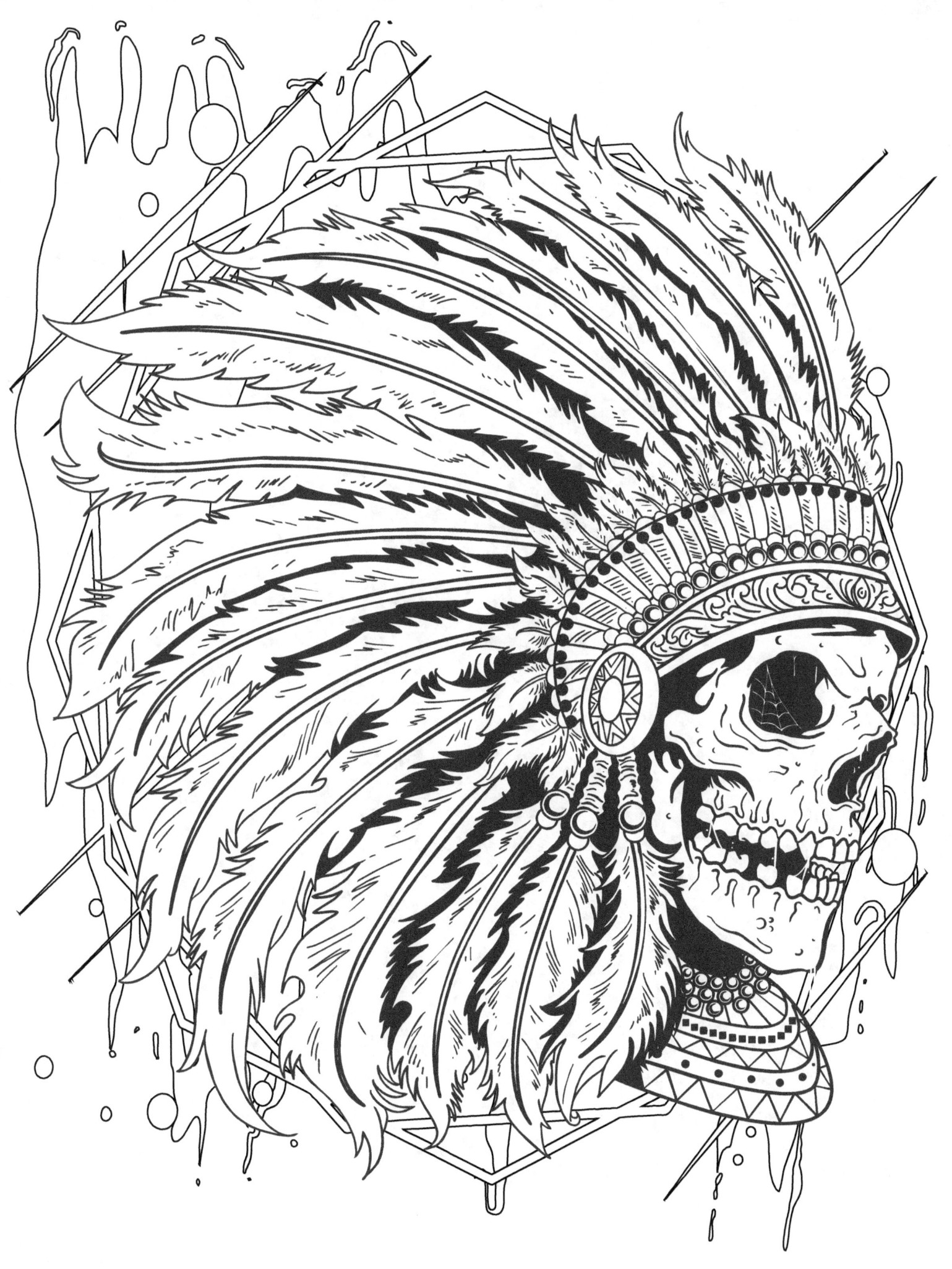

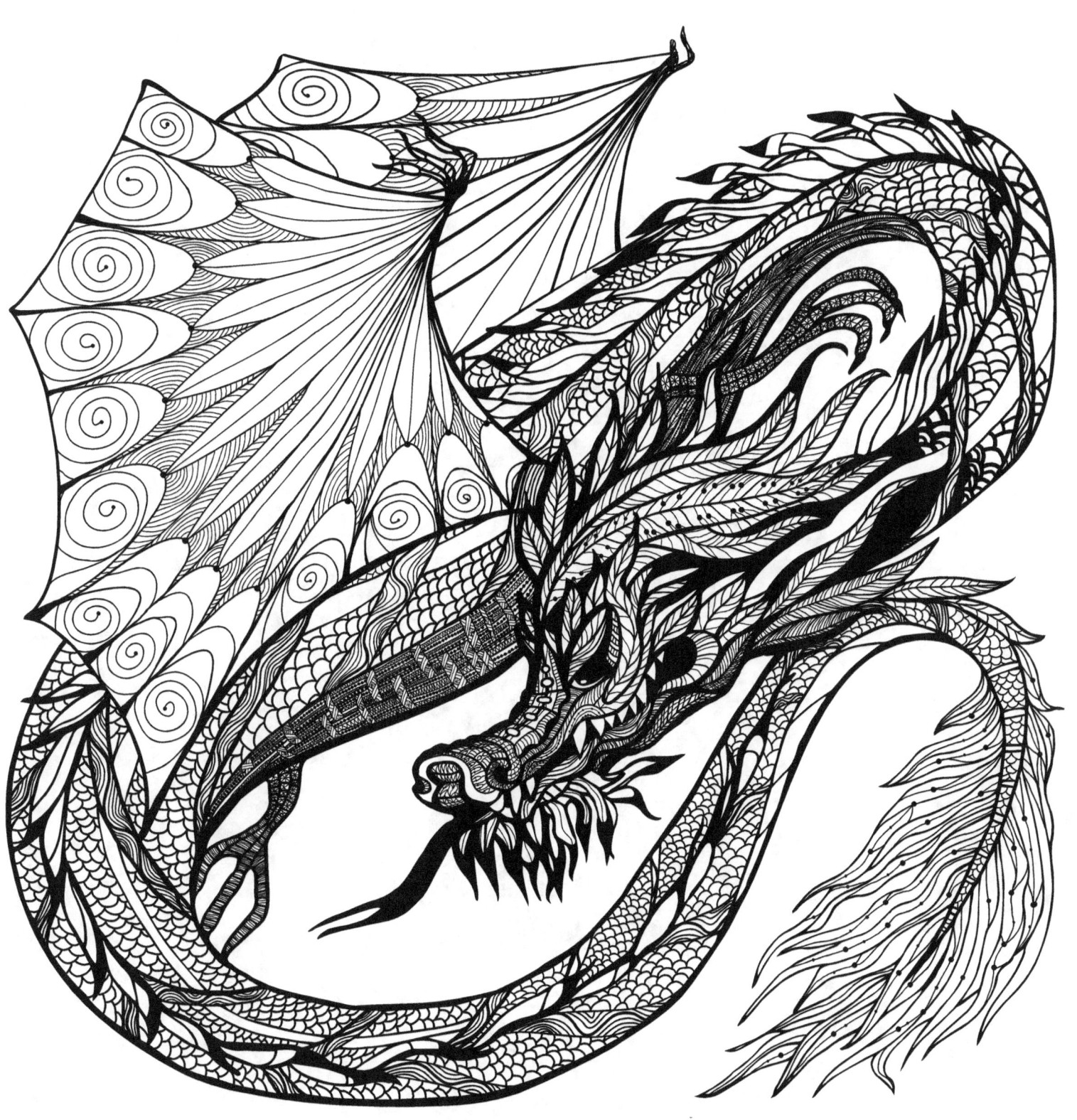

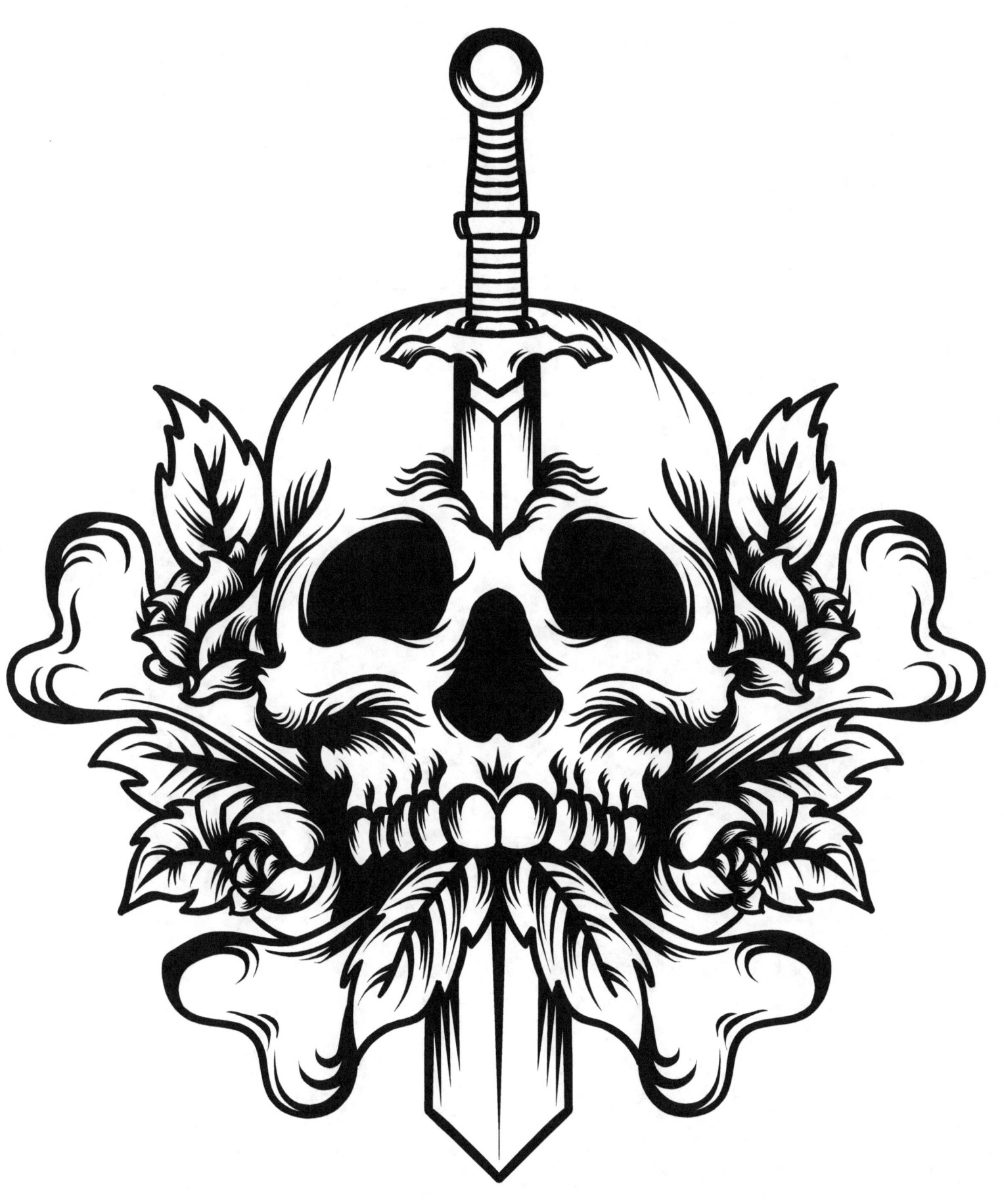

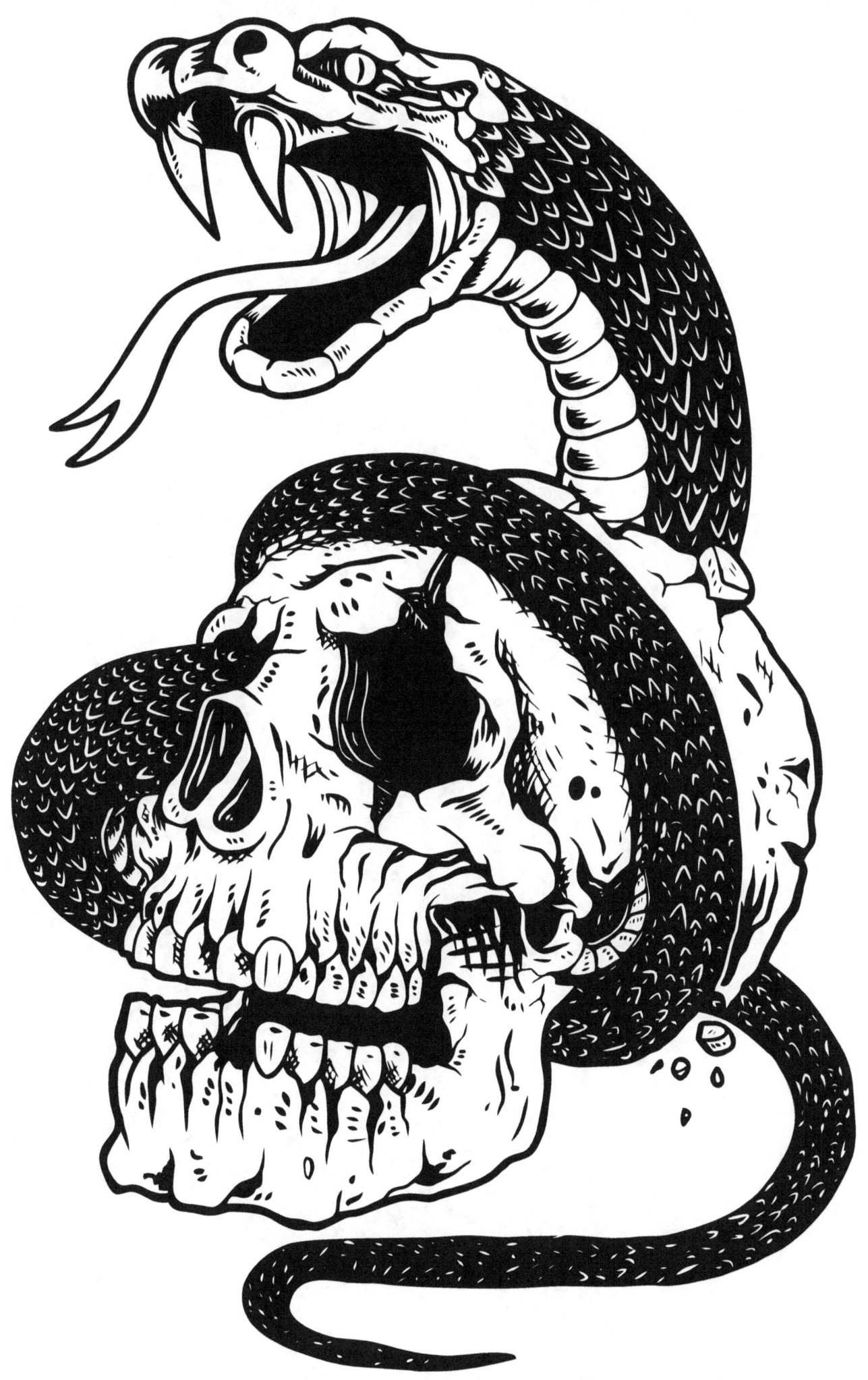

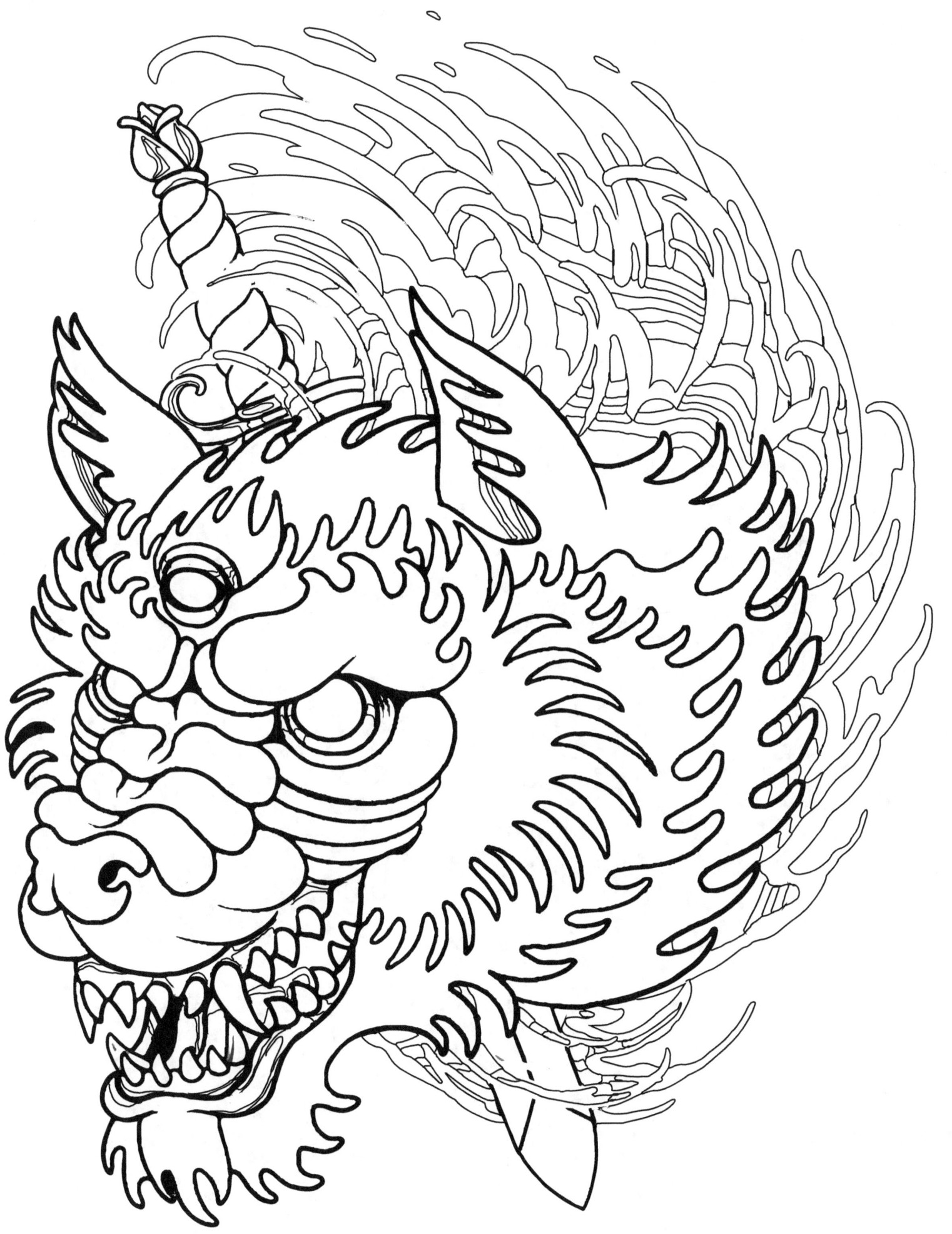

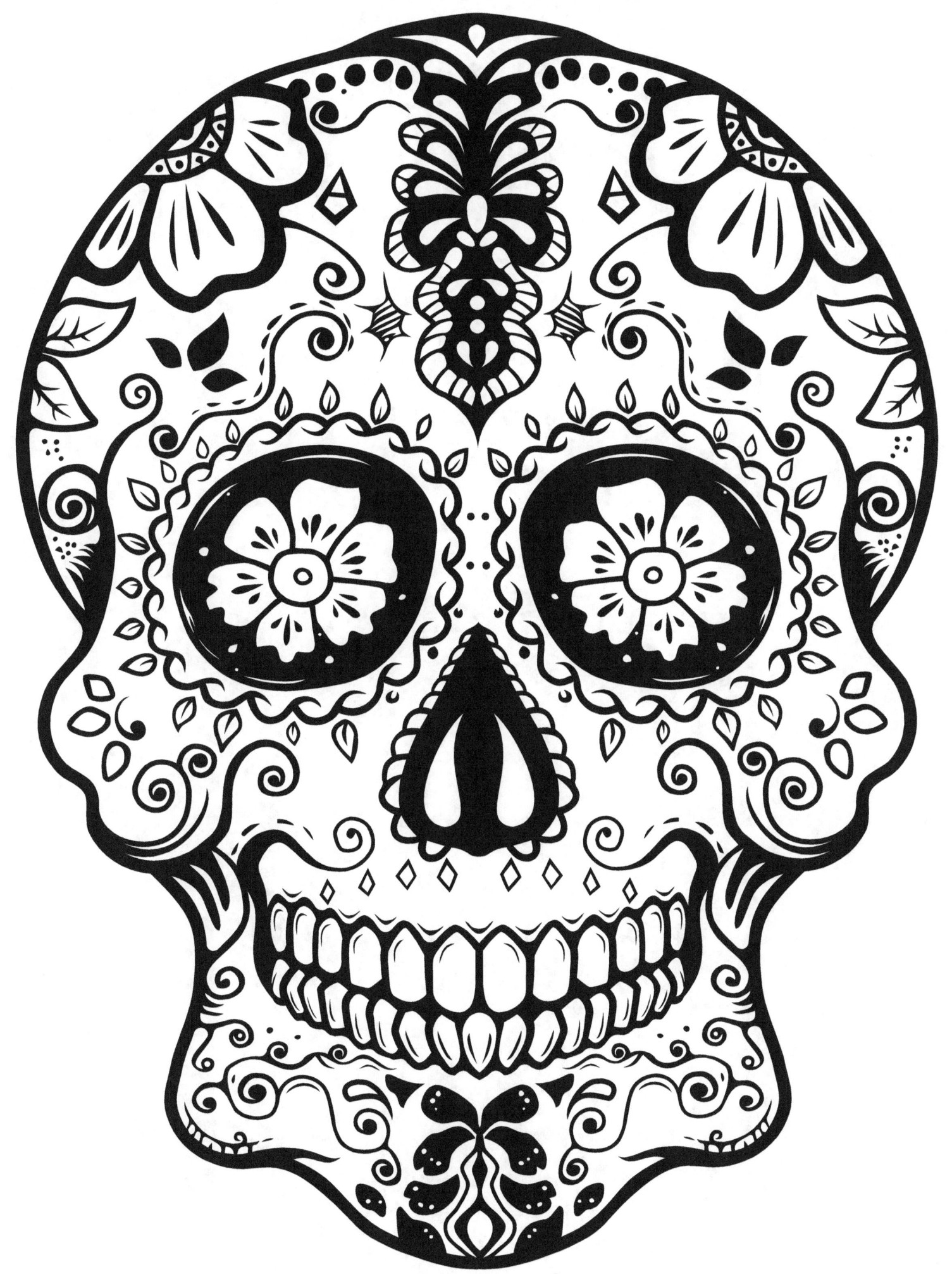

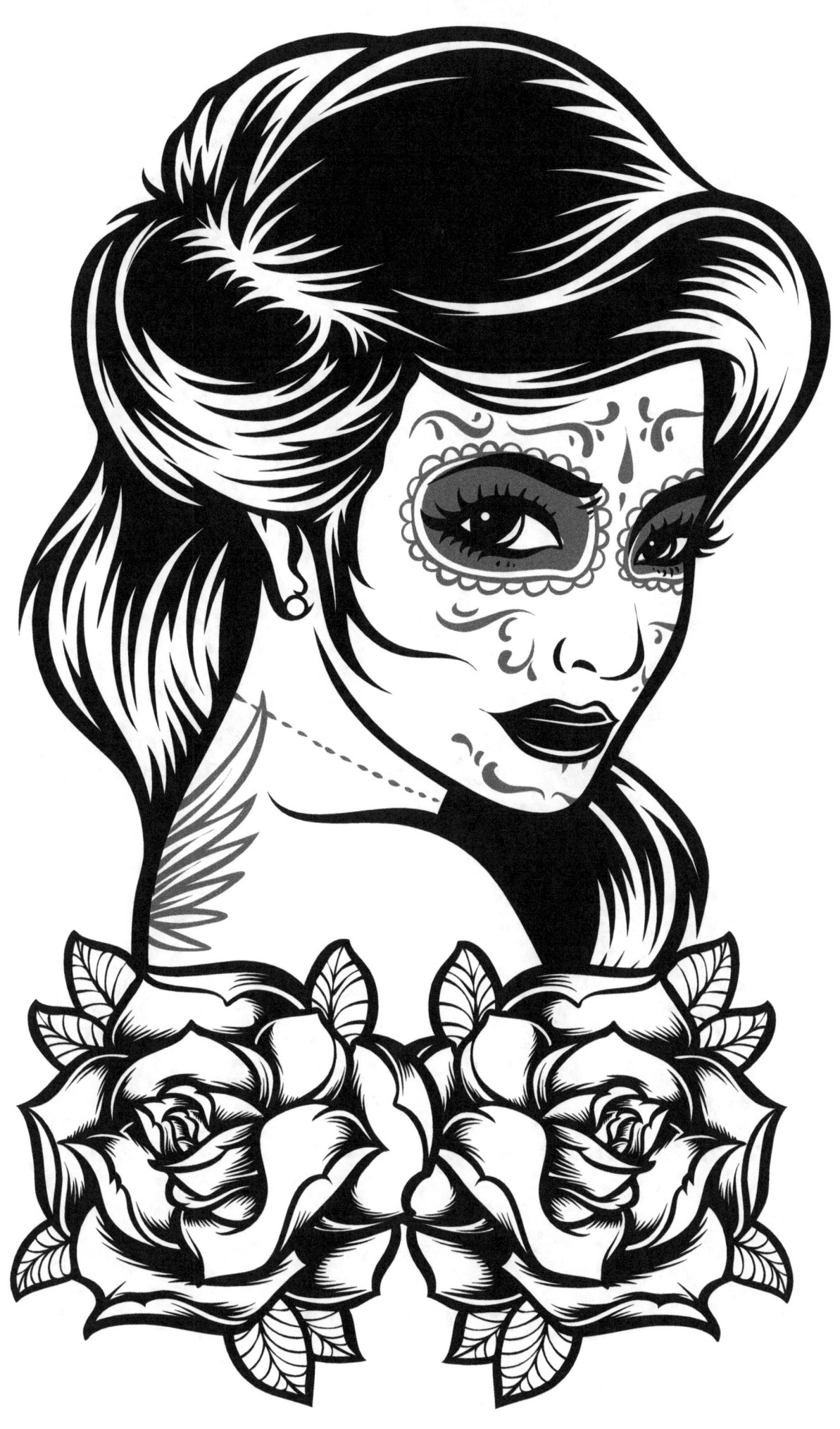

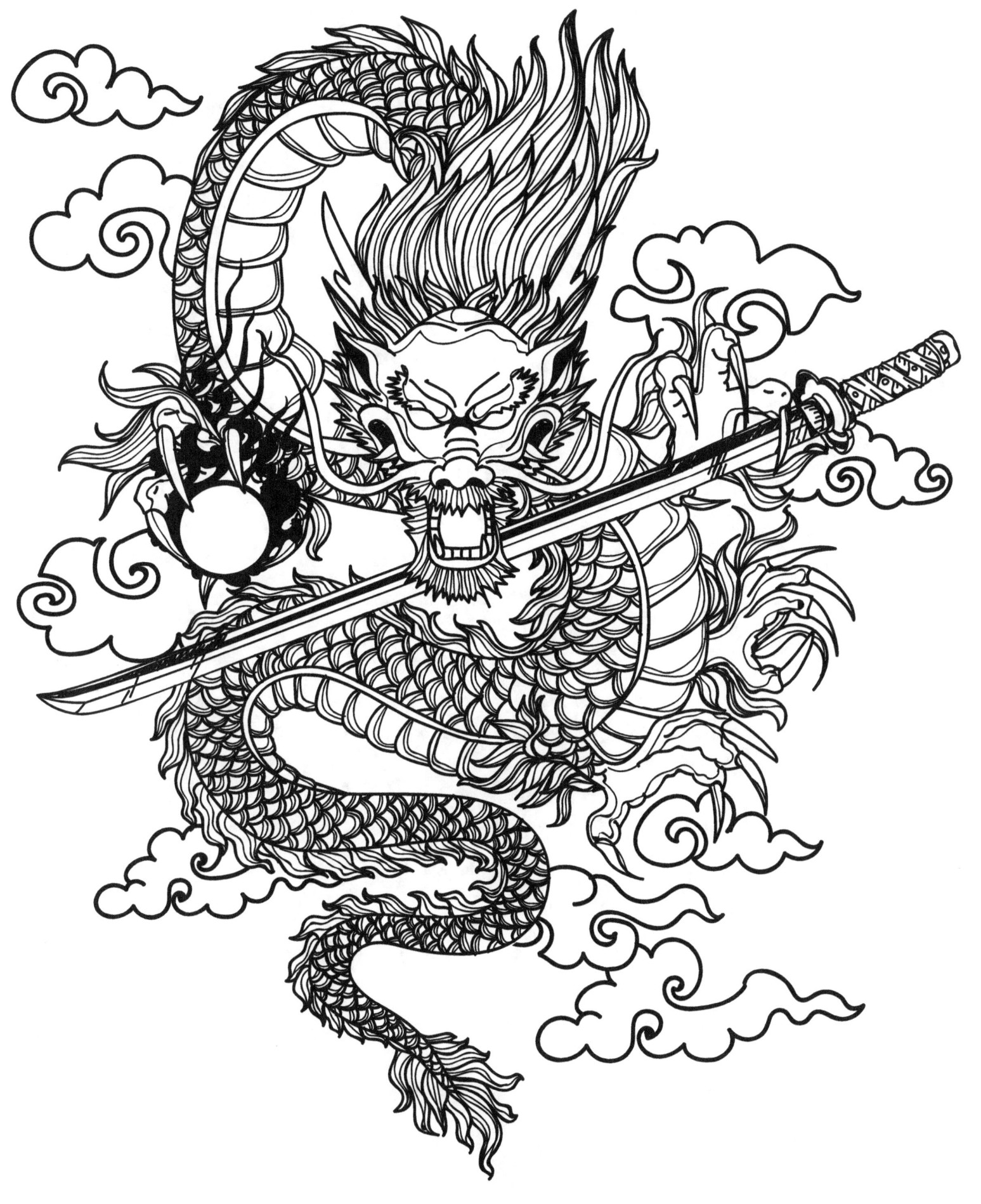

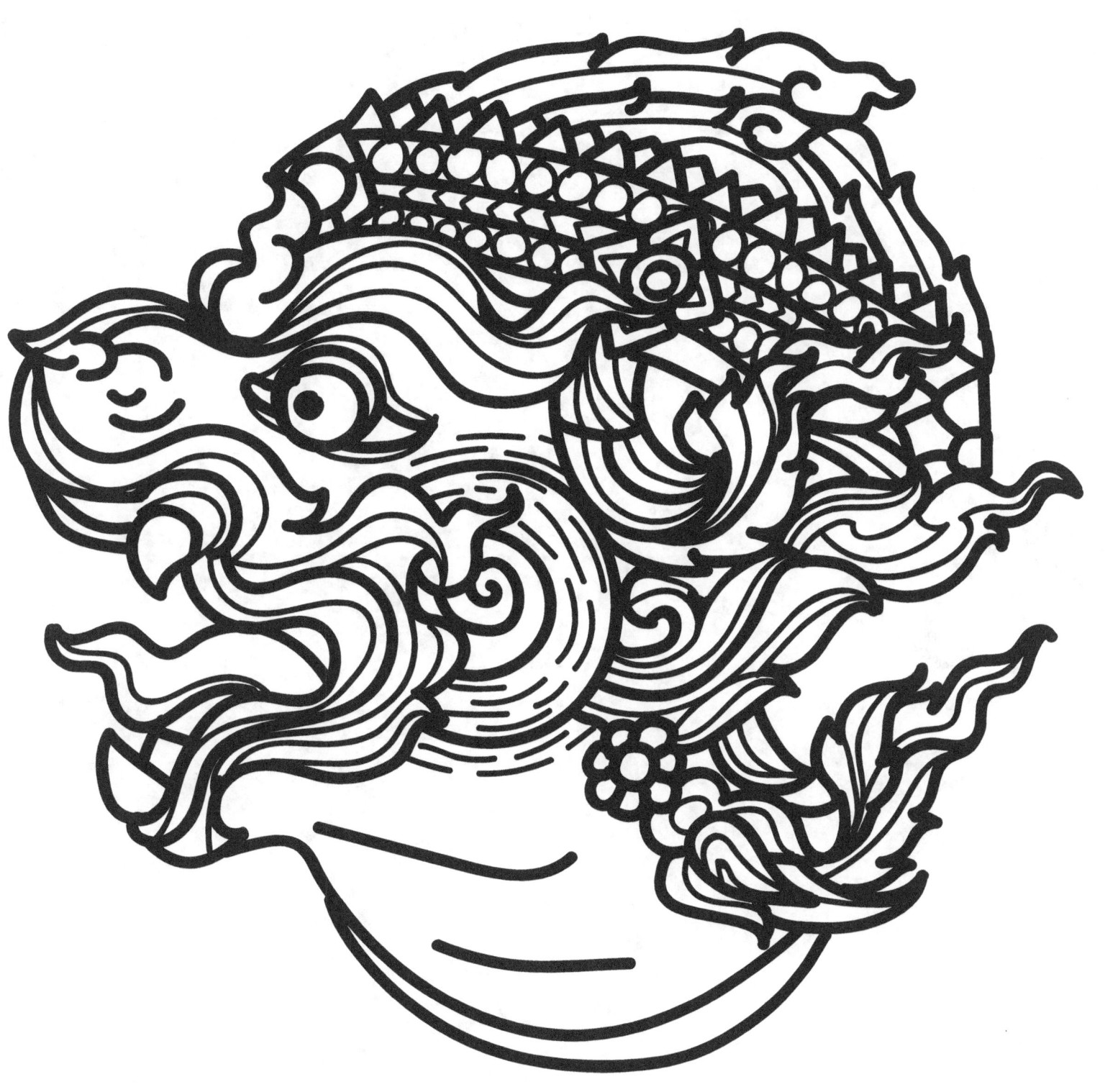

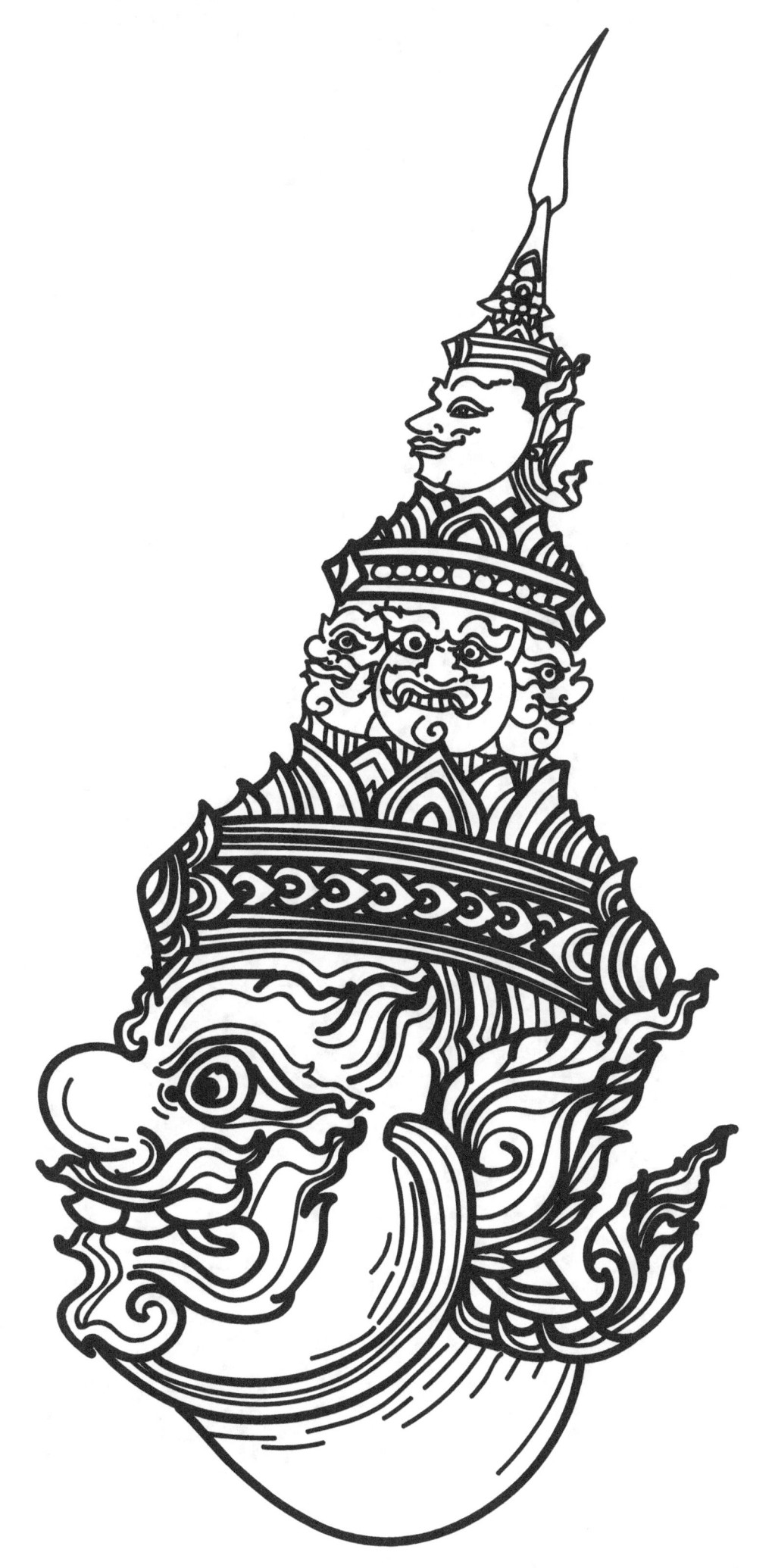

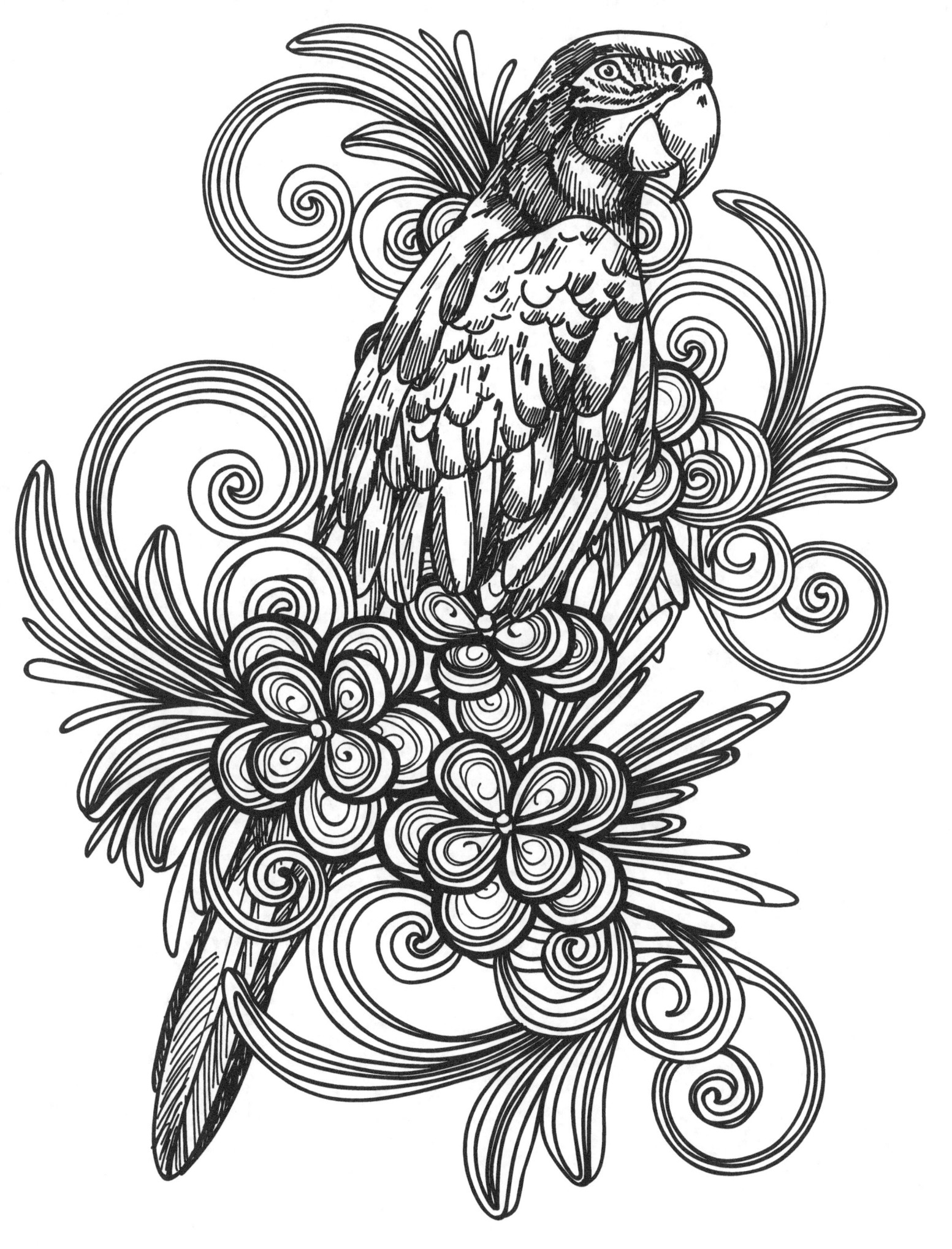

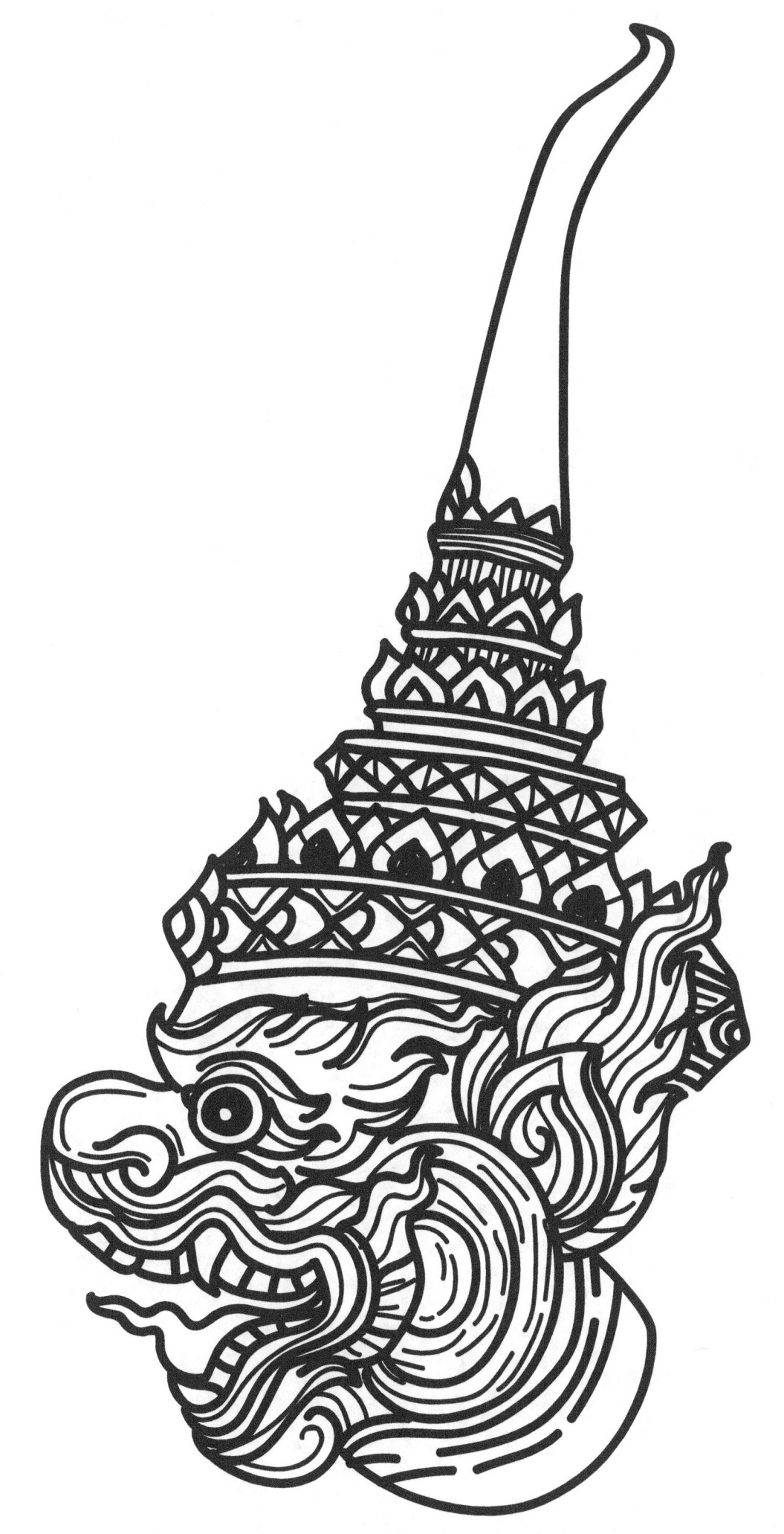

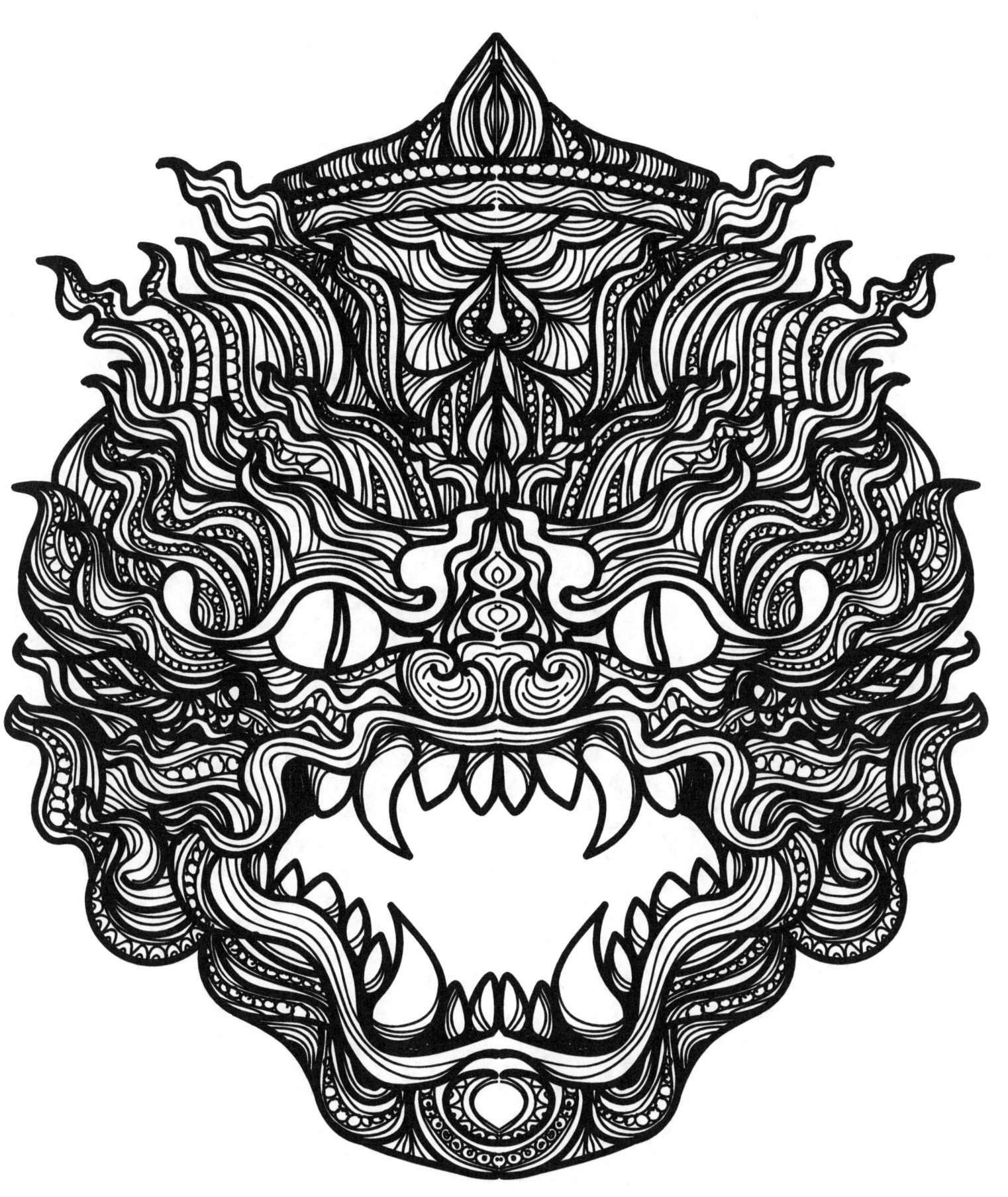

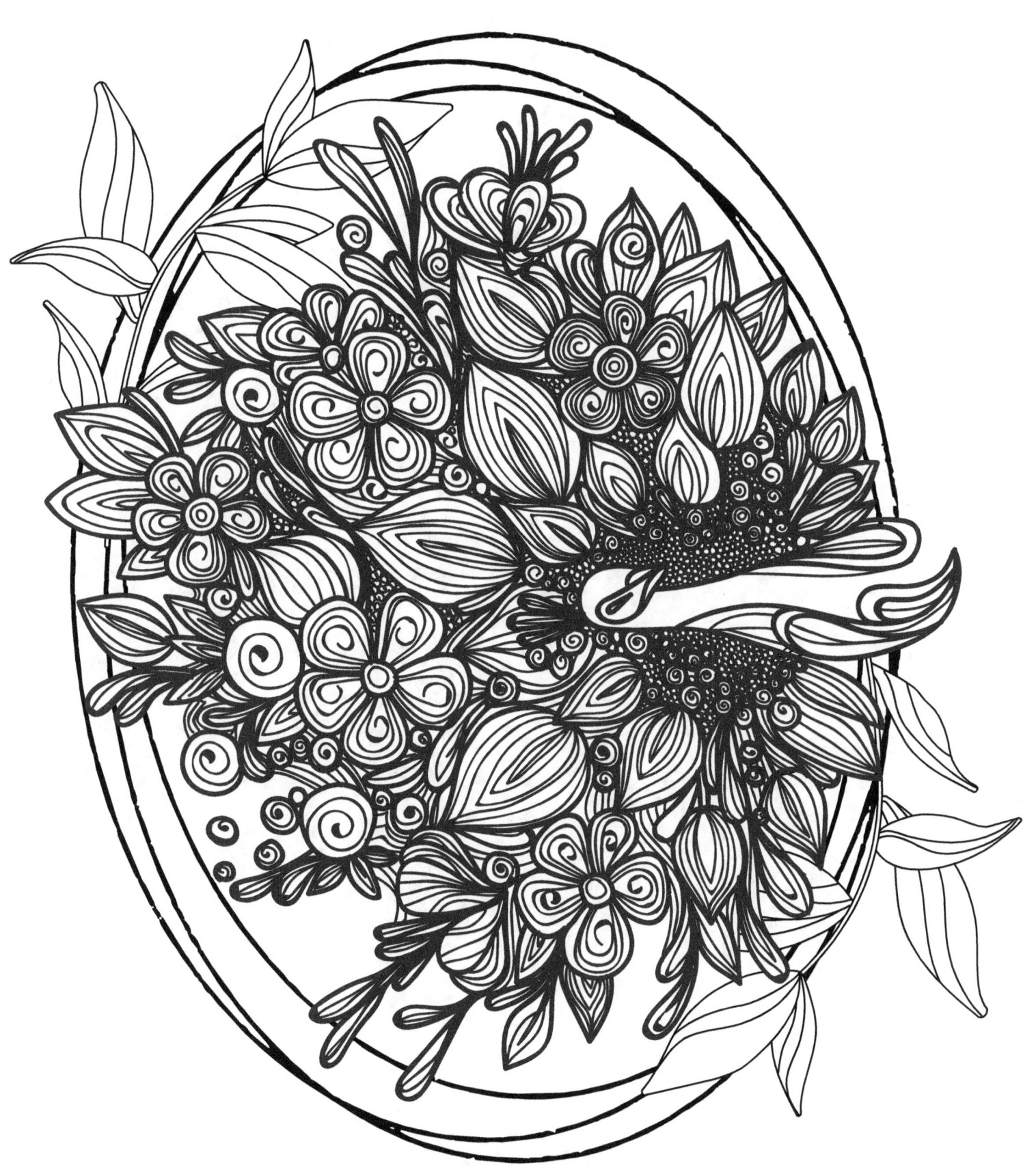

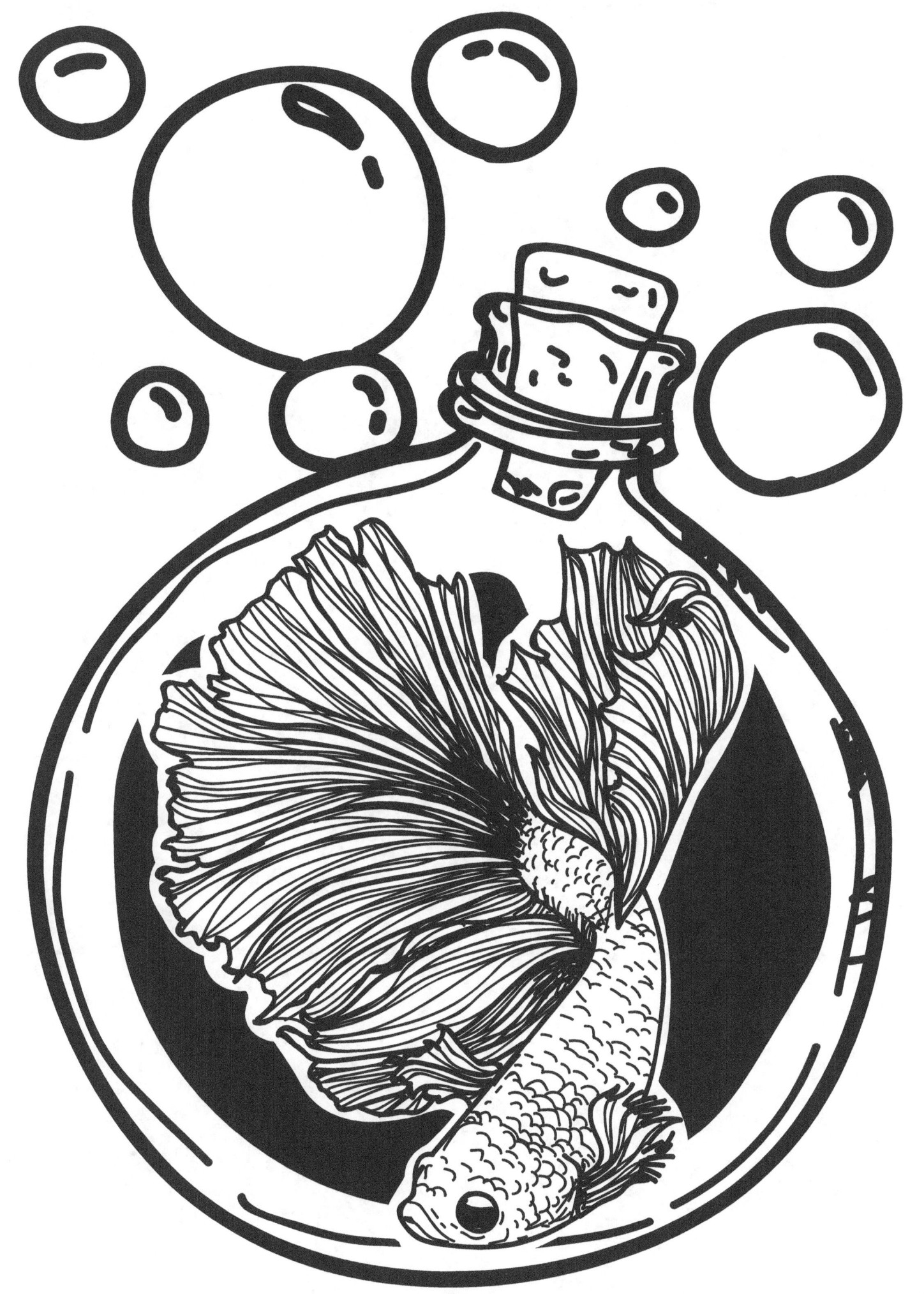

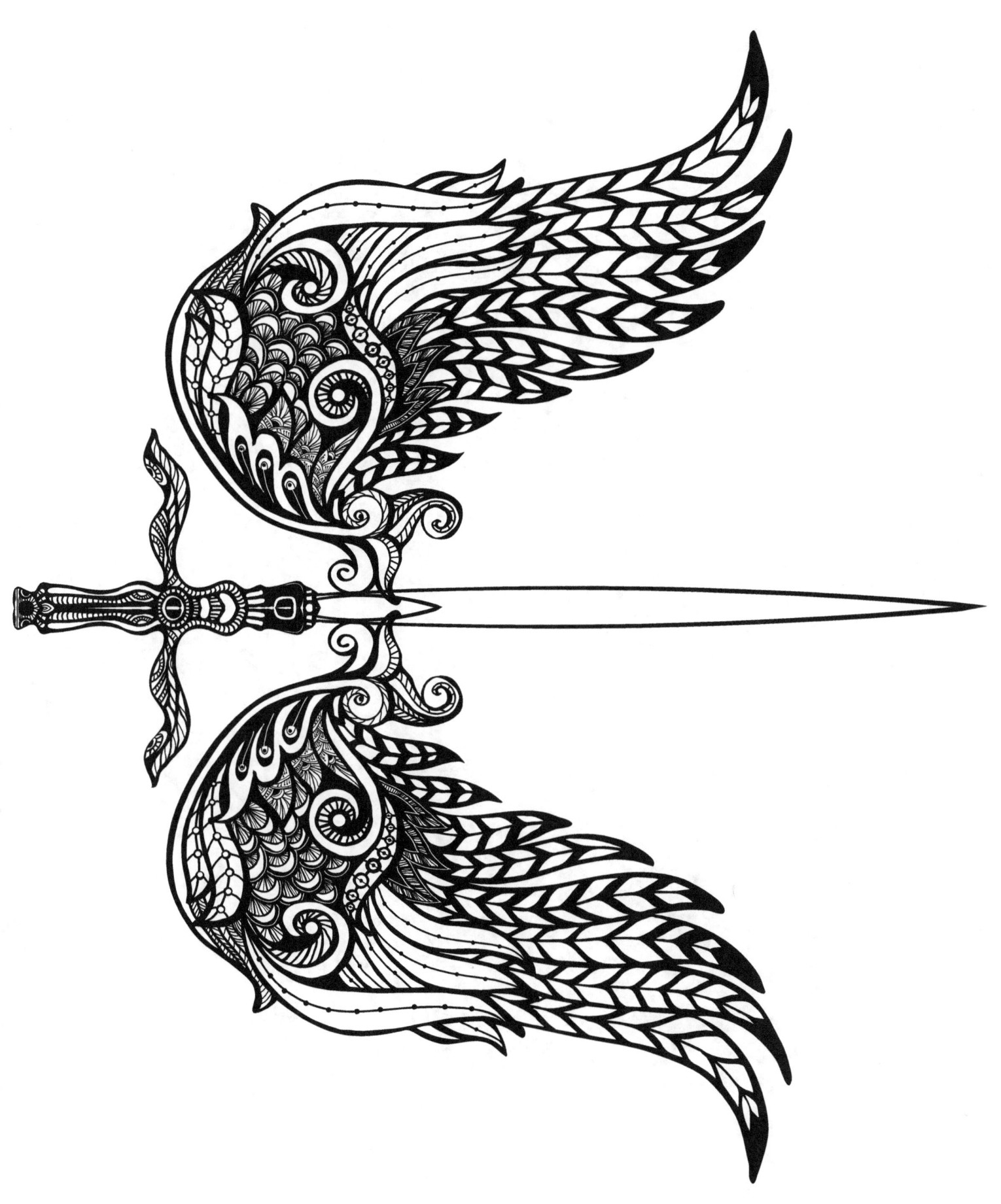

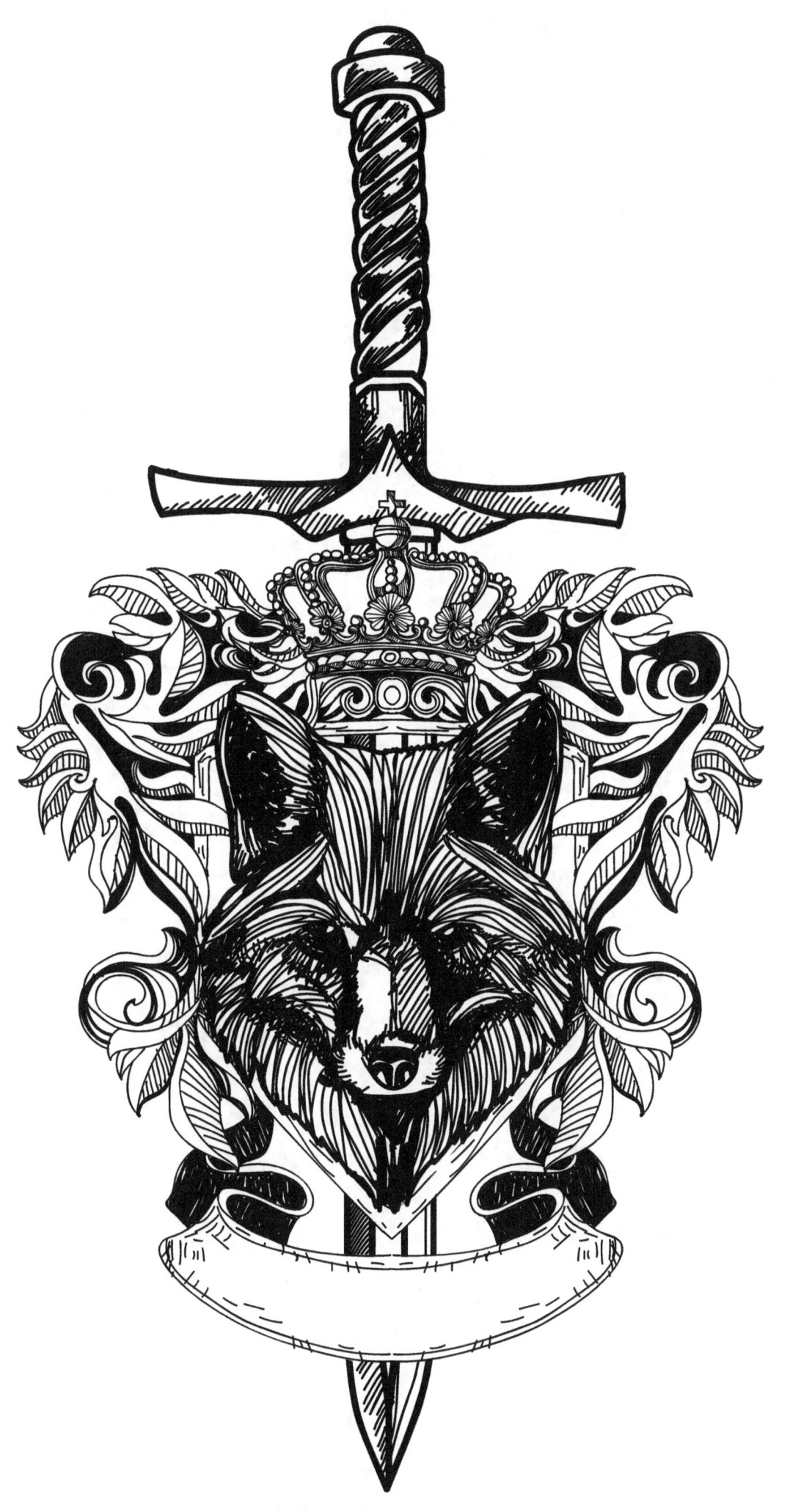

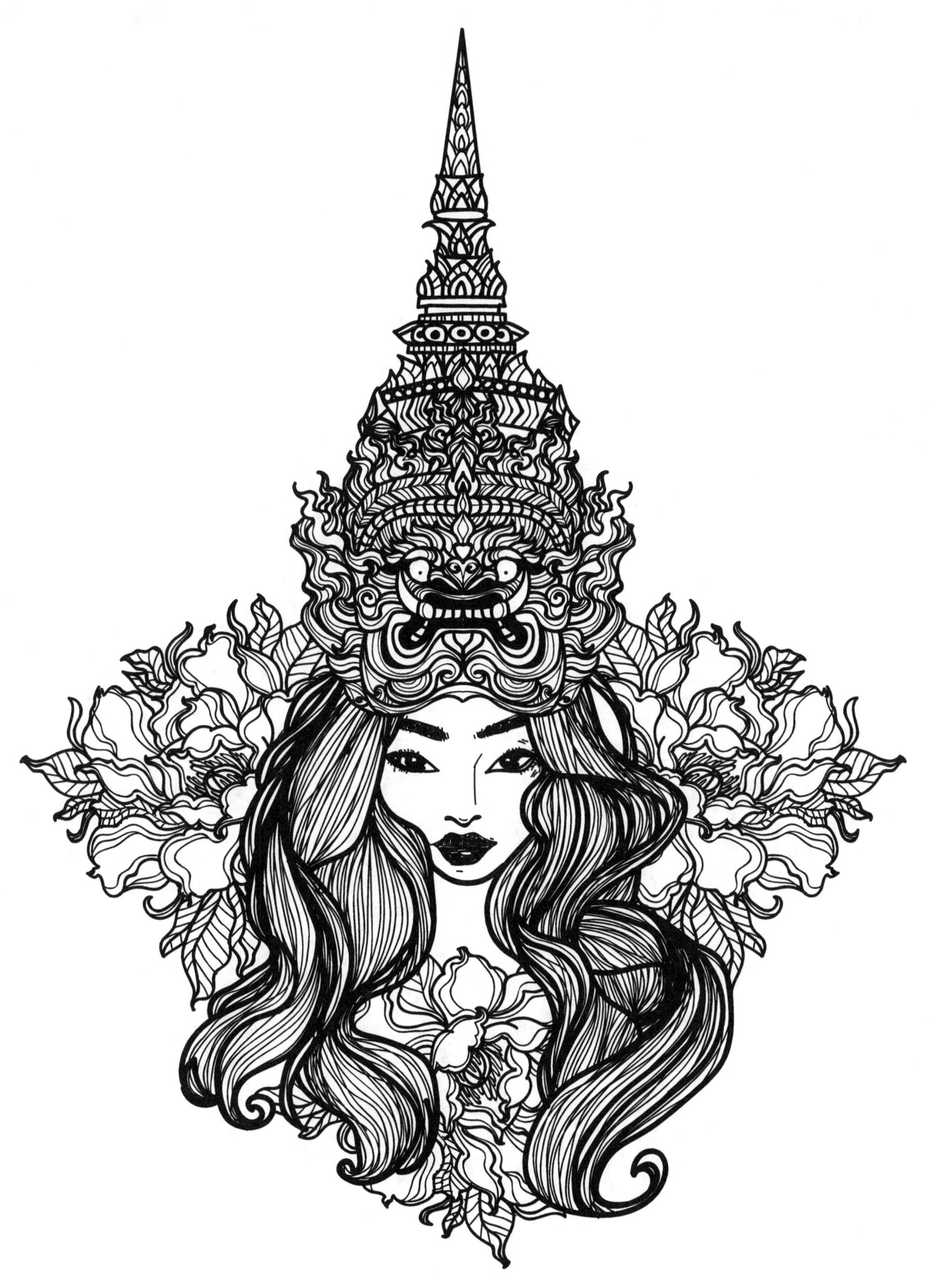

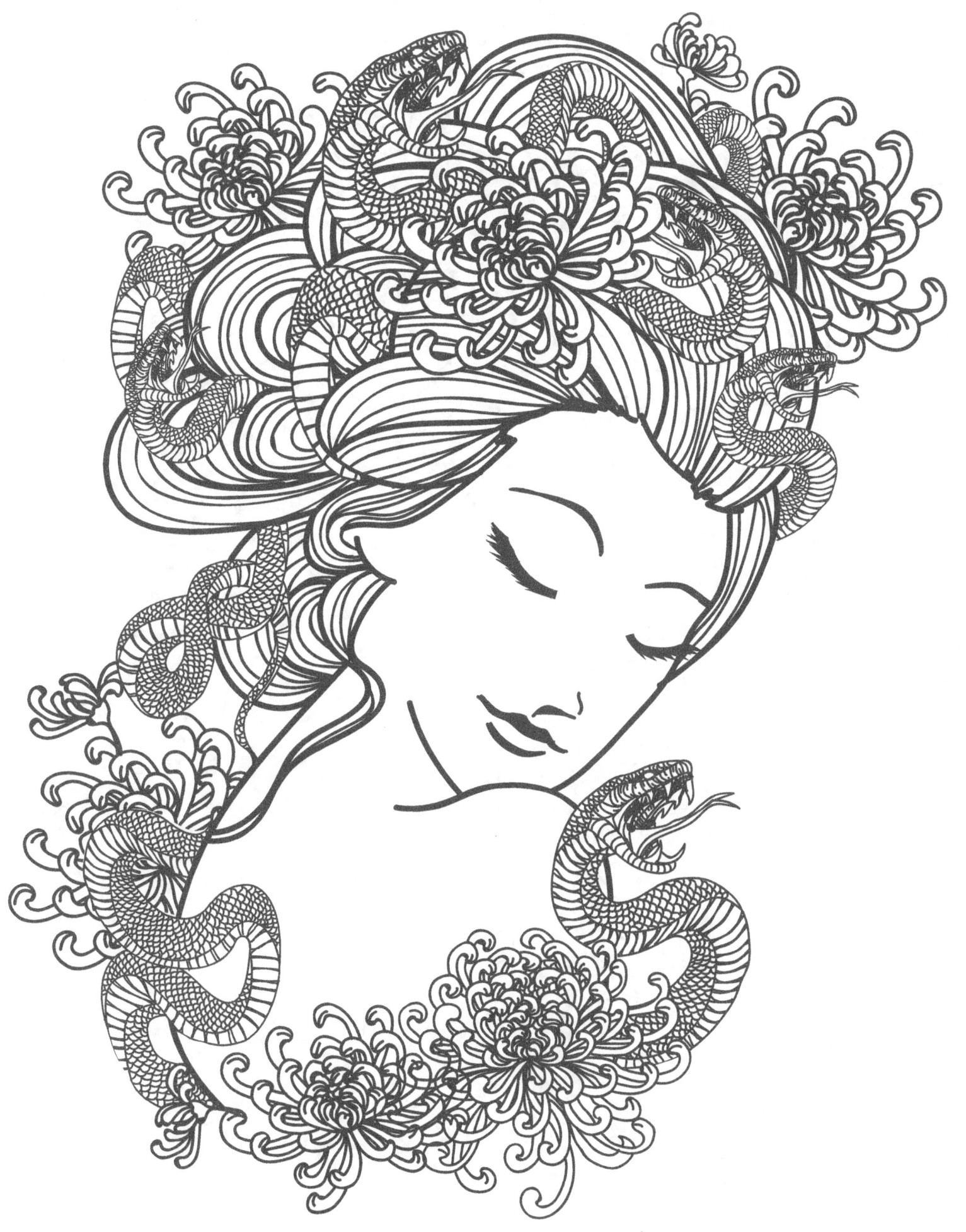

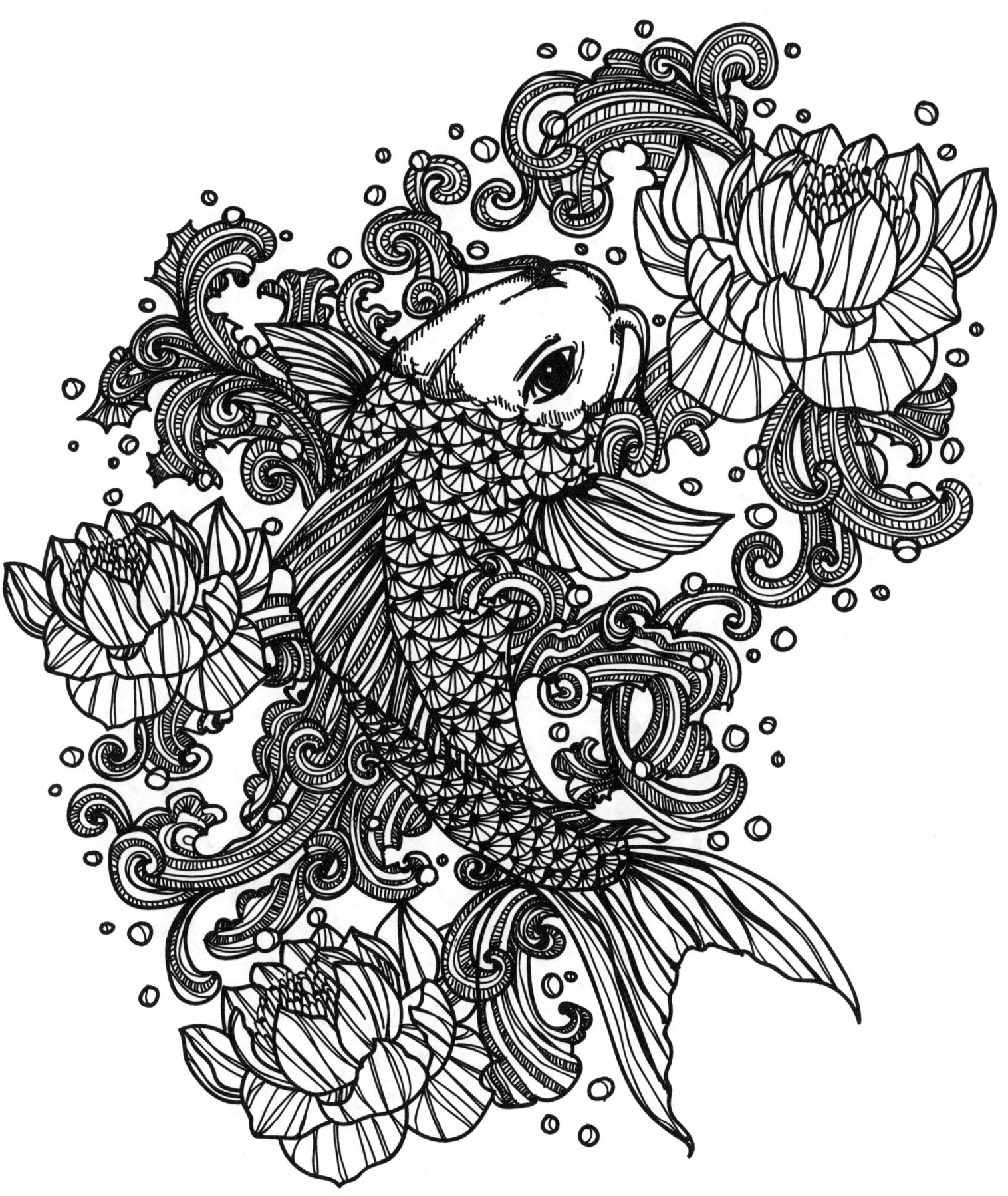

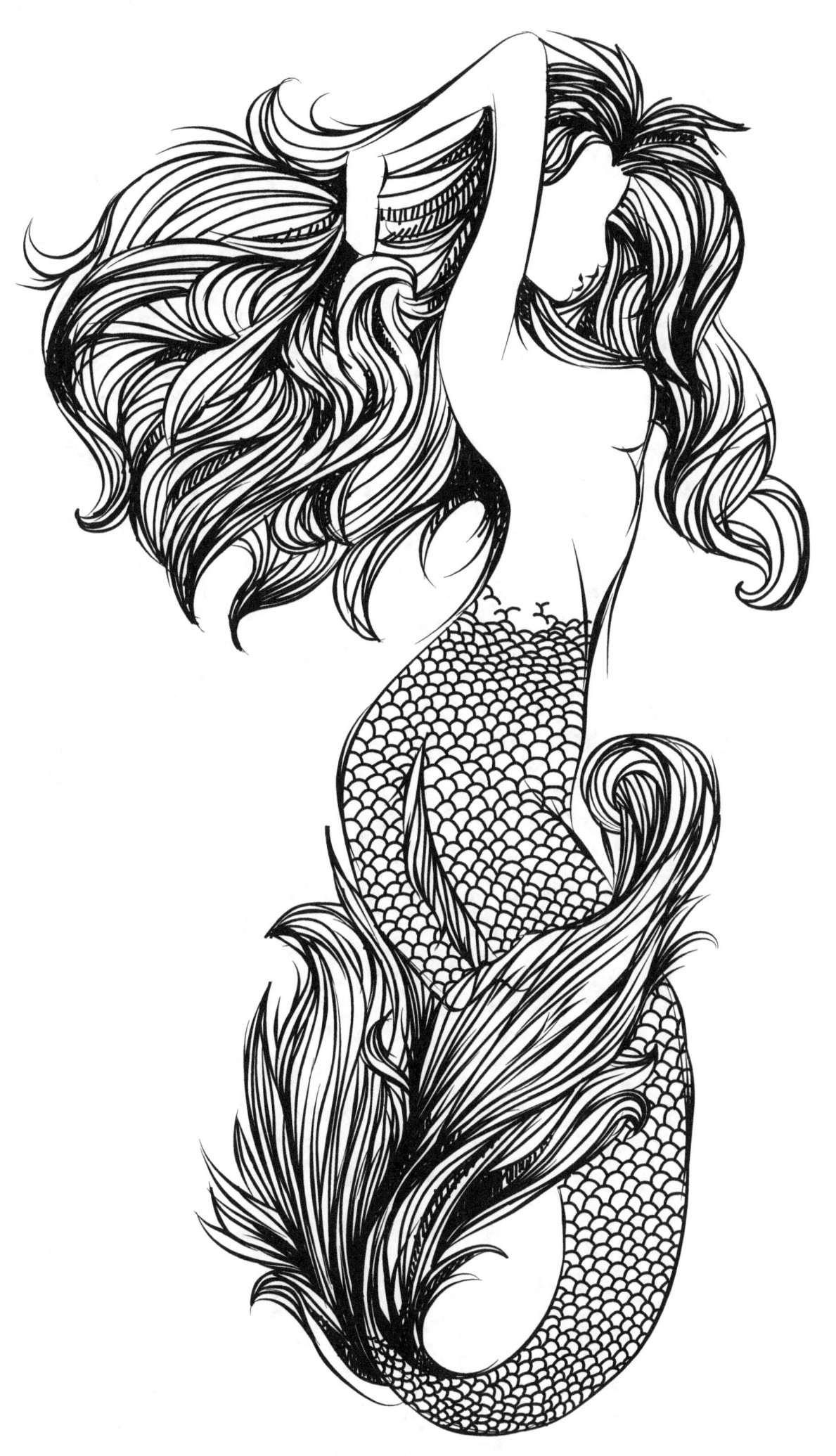

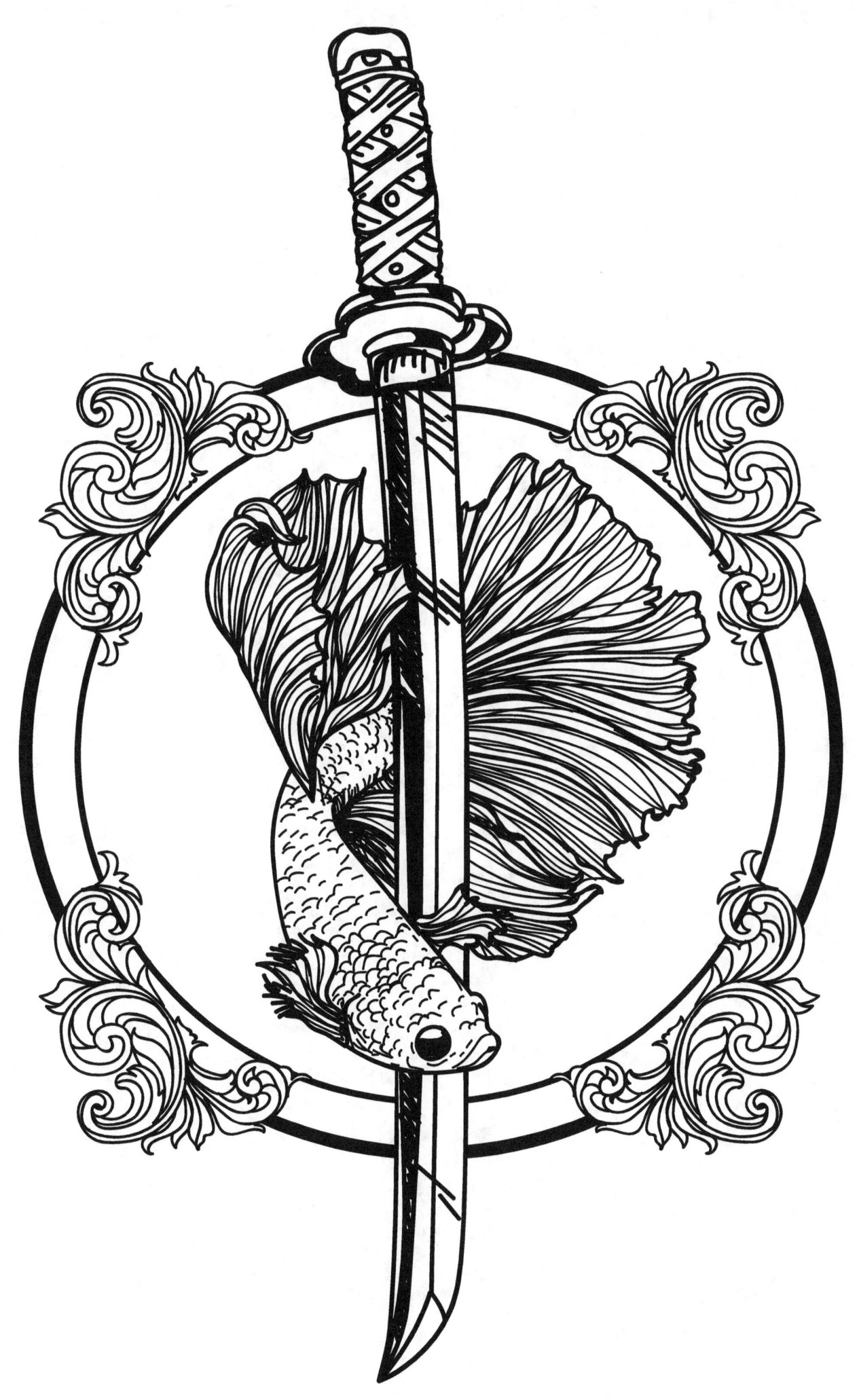

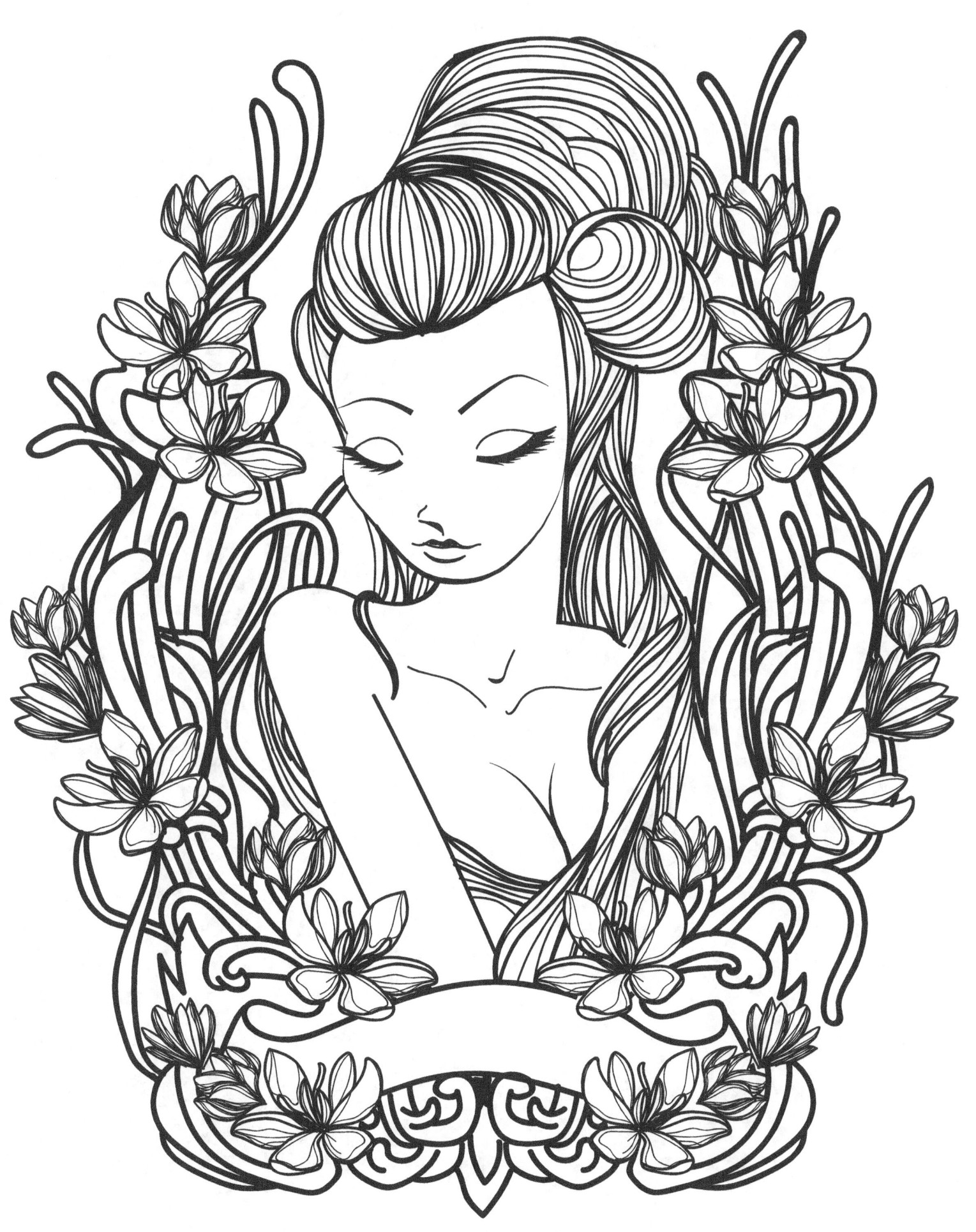

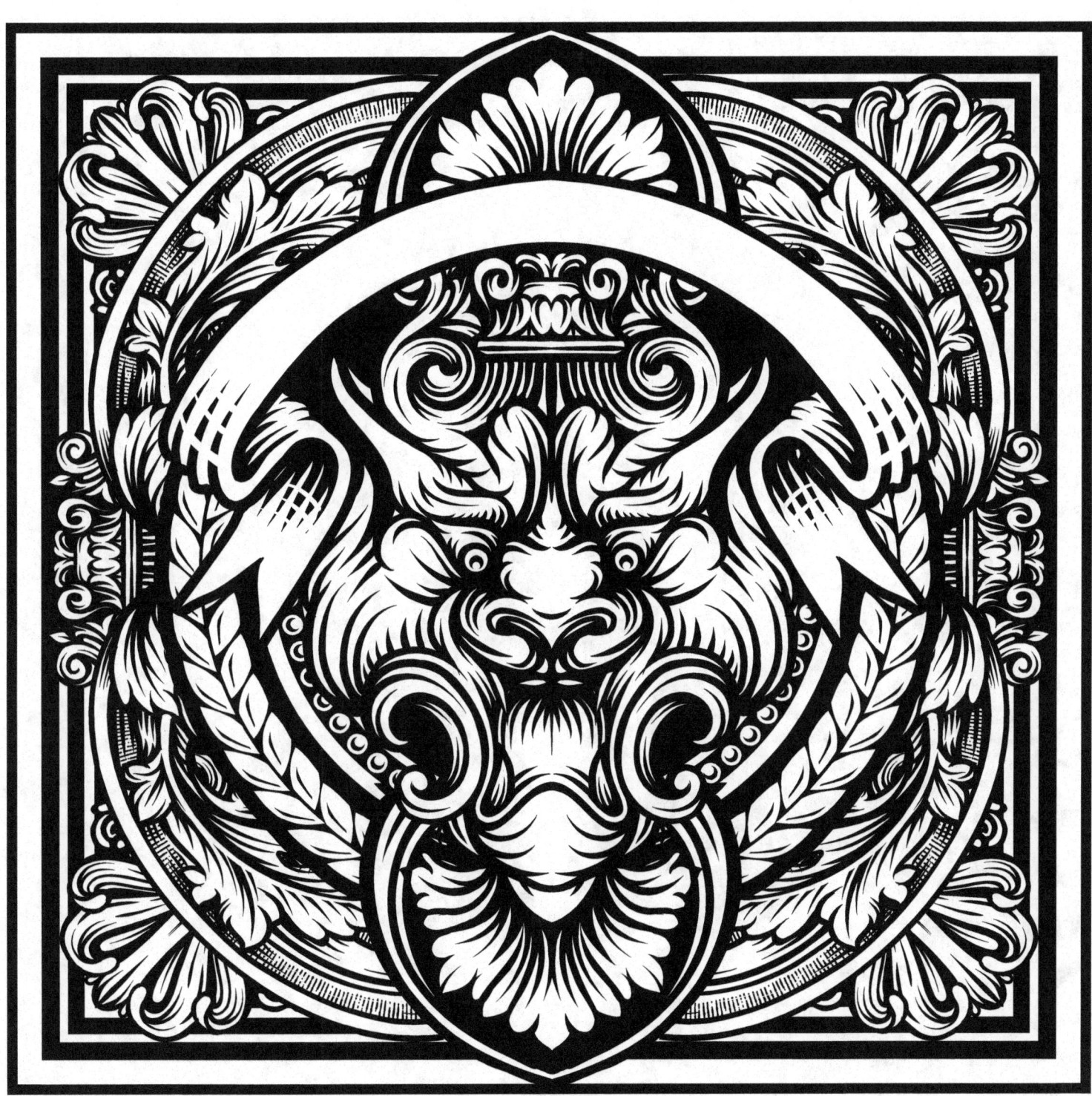

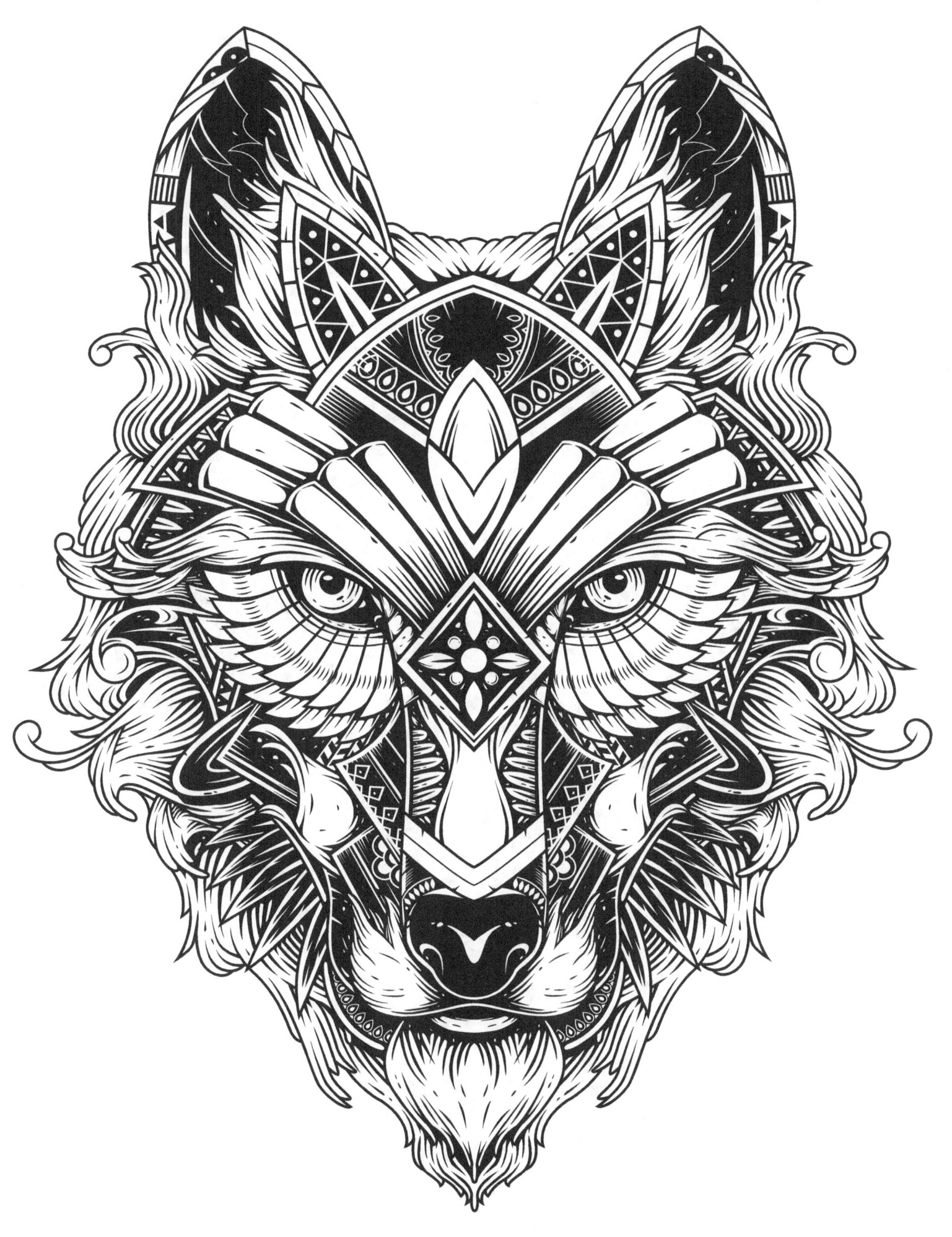

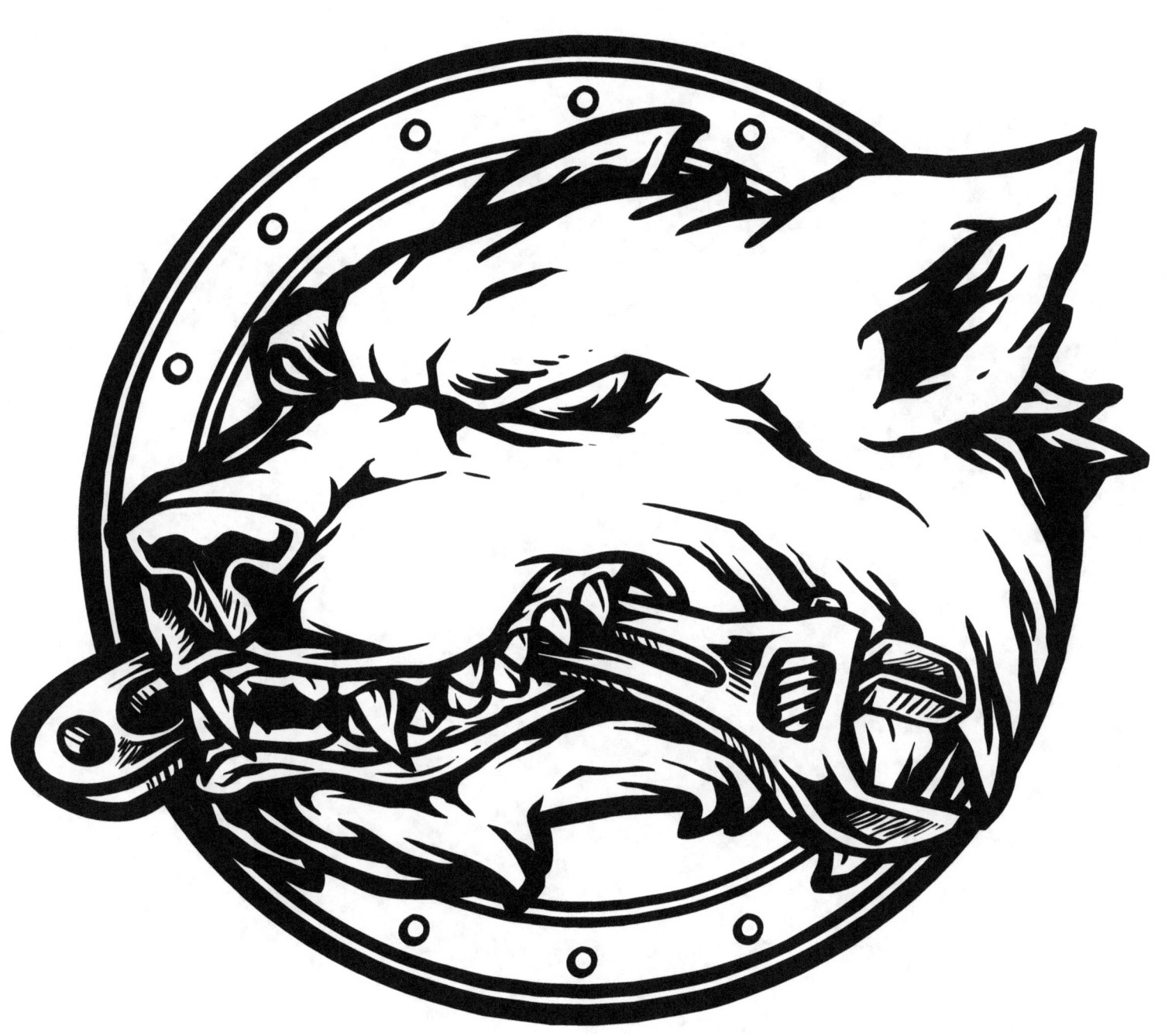

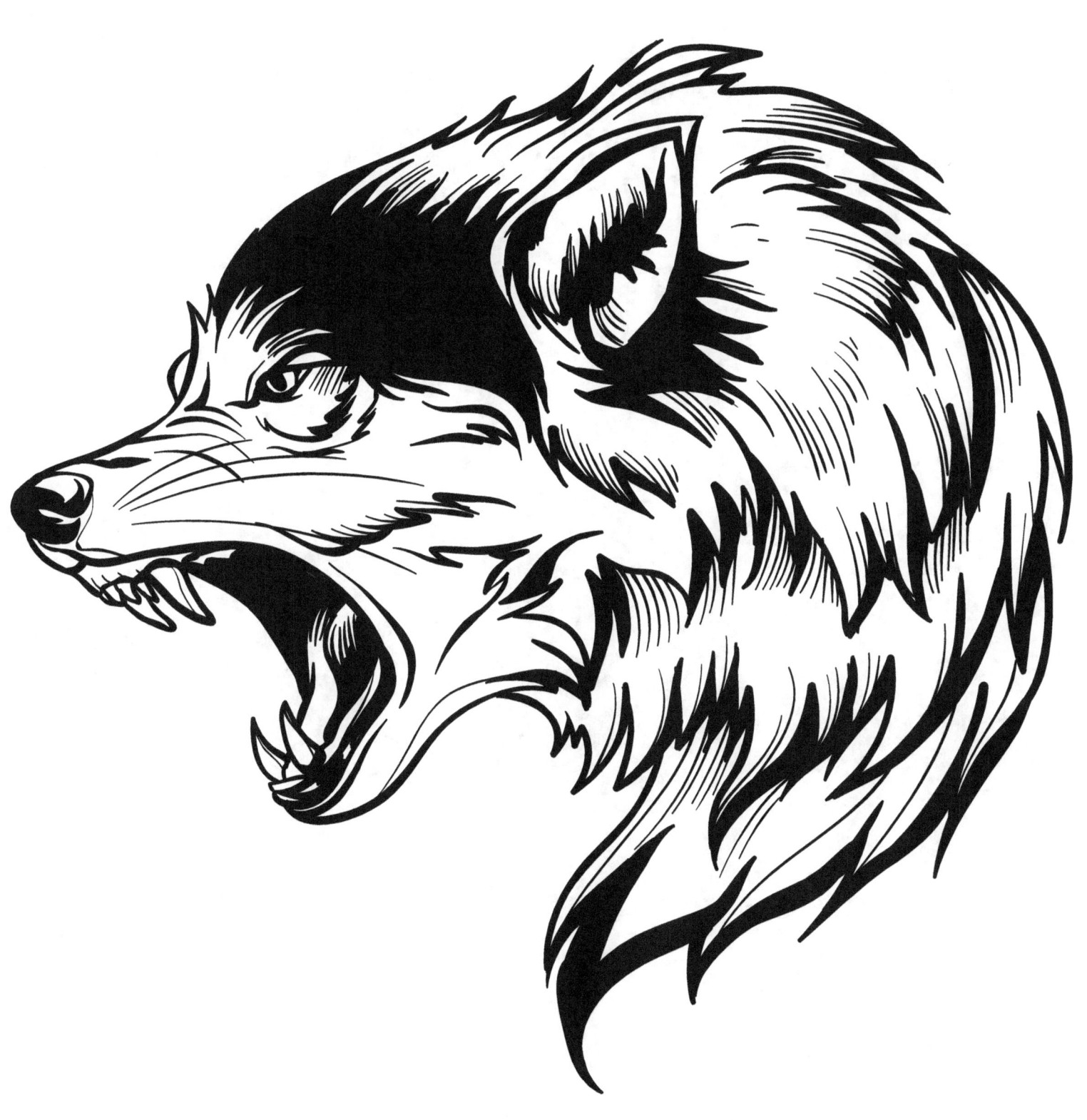

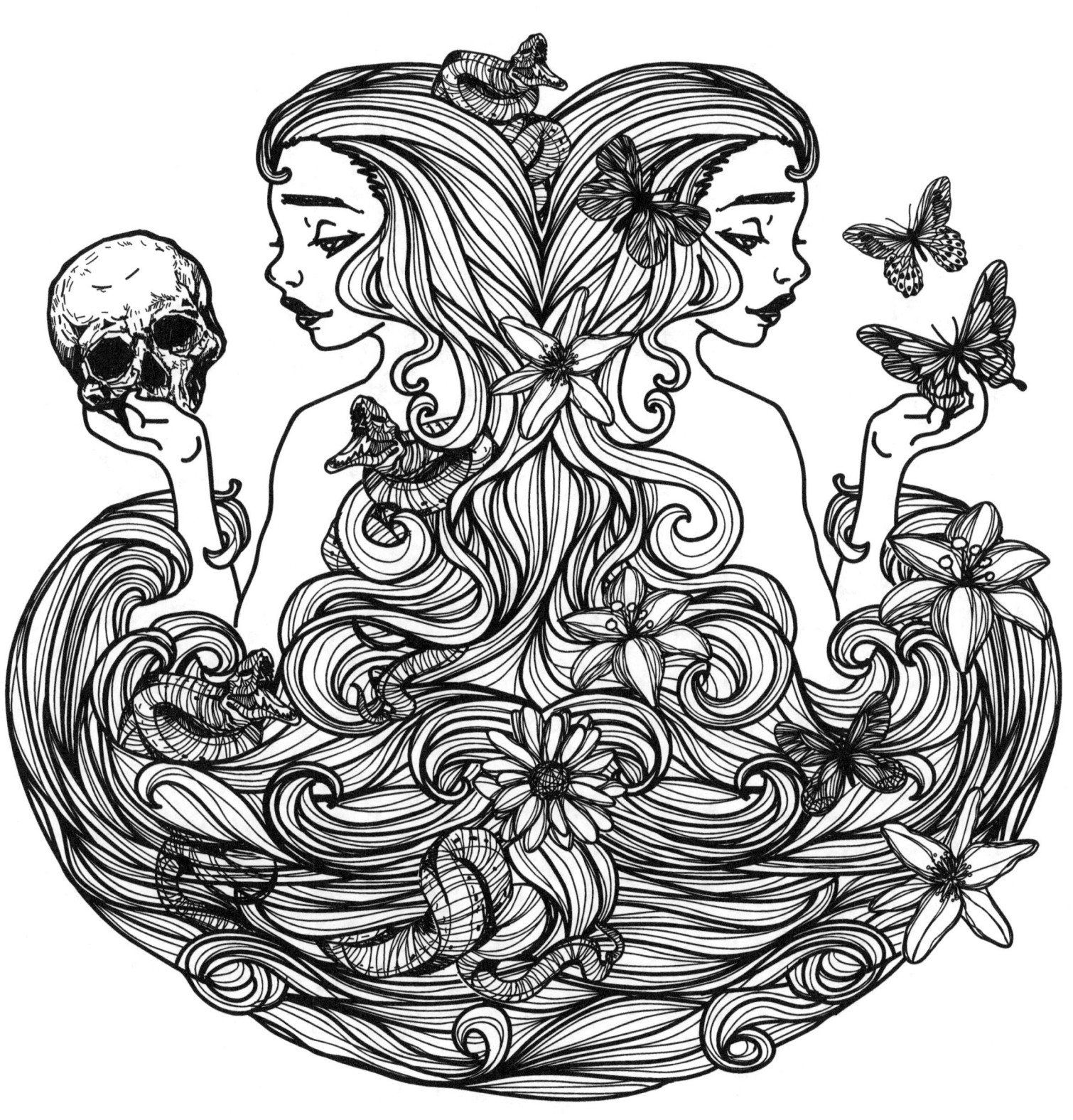

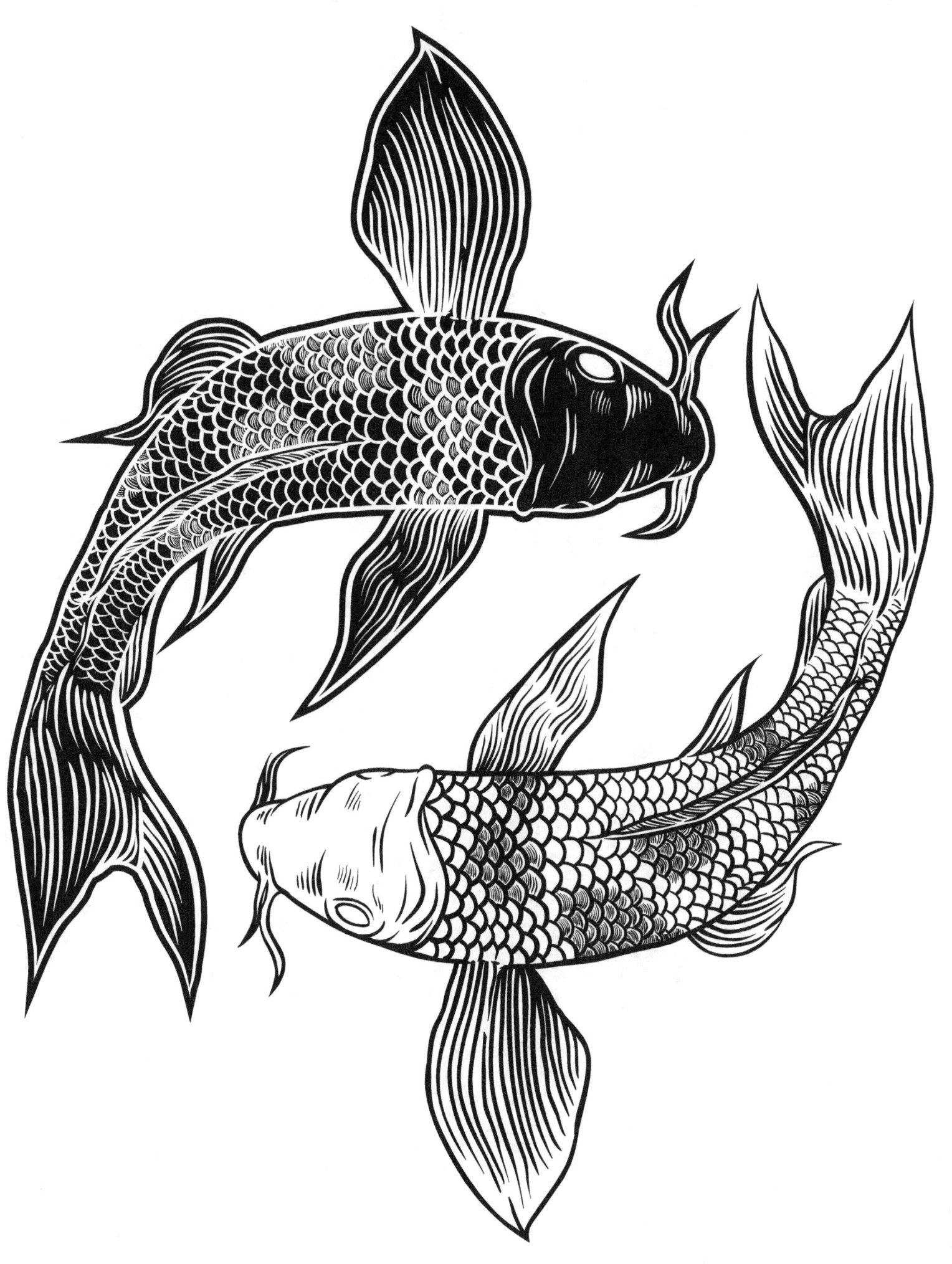

www.ingramcontent.com/pod-product-compliance
Lightning Source LLC
Chambersburg PA
CBHW080545220526

45466CB00010B/3036